FINER POINTS
IN THE SPACING
AND ARRANGEMENT
OF TYPE

Finer Points
in the
Spacing
&
Arrangement
of Type

BY GEOFFREY DOWDING

HARTLEY & MARKS PUBLISHERS INC.

HARTLEY & MARKS PUBLISHERS INC.
Box 147, Point Roberts, WA 98281
3661 West Broadway, Vancouver, BC V6R 2B8

First published in 1954
by Wace & Company Ltd, London
Second edition 1957
Third edition 1966
Revised edition 1995

Typeset by The Typeworks
Printed & bound in the USA

If not available at your local bookstore,
this book may be ordered directly from the publisher.
Send the cover price plus three dollars fifty for
shipping and handling to the appropriate address above.

Library of Congress Cataloging-in-Publication Data

Dowding, Geoffrey
Finer points in the spacing & arrangement
of type / by Geoffrey Dowding.
p. cm.
Includes bibliographical references and index.
ISBN 0-88179-119-9
1. Type-setting. 2. Letter spacing. I. Title. II. Title:
Finer points in the spacing and arrangement of type.
Z253.D69 1992
686.2'2—dc20 92-35936
CIP

Typography to-day does not so much
need Inspiration or Revival as Investigation.
Stanley Morison
in *First Principles of Typography*, 1951

AUTHOR'S NOTE: *We think that typography has
always needed, and still needs, the first, can often
refresh itself by reference to the best work of earlier
days, and certainly needs unremitting investigation
of its ever-widening field.*

. . . the success of printing lies in never
for one instant relaxing in the inspection
of details until the book is actually bound.
Bruce Rogers in *PI*, 1953

One more attribute the modern typographer
must have: the capacity for taking great pains
with seemingly unimportant detail. To him,
one typographical point must be as important
as one inch, and he must harden his heart
against the accusation of being too fussy.
Hans P. Schmoller in BOOK DESIGN TODAY,
Printing Review, Spring 1951

CONTENTS

PART ONE

The Setting of Text Matter

PART TWO

The Setting of Displayed Matter

FOREWORD

I remember the day I acquired my copy of Dowding's *Finer Points in the Spacing and Arrangment of Type*. I spent the morning in Holborn, buying setting rules at 'Printer's Pie', & then went to T. N. Lawrence and Son in Bleeding Heart Yard to buy a brayer. After that I met a friend and went to Gee & Watson in Fleet Street to see about buying a fount or two of type. We had heard that they were selling off a few things, & thought that perhaps we could buy some rarities: used founts, in case, in good condition. There were a few other buyers there, people with gleams in their eyes and the furtive looks of secret hoarders, queuing up in front of a man with a large scale who weighed cases of type and charged 30p. a pound. All around were corridors of type frames full of cases, & as we looked for the names we lusted after—Trump Mediaeval, Bembo, Poliphilus & Blado—men hurried past us pushing stacks of type cases on dollies. They wheeled to a double loading door opening onto an alley, dumped the type from the cases out of the door into a waiting dump truck below, and piled the empty cases next to the door by a chalked sign which read, '£1 each'.

I did find some treasures which I am still using, fifteen years later: some 48 point Trump, large founts of Poliphilus & Blado, a small case of brass rule, and a copy of the third edition of this book, 'published in the interests of fine typography', as a quiet colophon note asserts. The book was lying on the table where the type was being weighed, & I asked if I might have a look at it. 'Take it, mate. We'll have none of that stuff here any more', & the book was slung on top of the case being weighed. It might have come in at half a pound, say 15p.

At Barbarian Press, Dowding has achieved the familiar metonymic fame of Bartlett, Partridge or Collins, the man subsumed

into his work. Not that the book is one which I consult regularly for specific answers, although I often do so, but rather that I dip into it for reassurances about what has seemed sensible to the hand or the eye. The subject of the book, set out in the title, does not promise an answer to all the great questions, after all; it only makes clear, with a candour peculiarly workmanlike, that if you need to know anything about spacing & arranging type, this is the shop for it. It reminds me of George the Veg, the greengrocer in our village in Kent, who once fended off an enquiry I'd made about pippins: 'You'll best be asking yon Archie about that. He's your apple man.' Such discretion of experience also explains a good deal about the peculiar myopia of the English printing unions.

Because of the circumstances in which I bought the book, it has taken on a totemic aura for me. It is a useful tool and a frequently consulted reference, but it is as well a talisman, probably the first book I would try to acquire for a pressroom if I were to start all over again. Occasionally, I meet someone whose feeling for the book is similar to mine, & the attitude we share is not primarily a recognition of its usefulness so much as a fundamental affection for the sheer love of type and printing which Dowding evinces on every page. Indeed, these two reactions to the book, which are almost universally held by its owners as far as I can tell, rather sharply oppose one another in some ways. I am fervent in my arguments in support of either position, but find myself using the book at any given time distinctly for use or for pleasure, with frowning purpose or leisurely indulgence, but not both. There is something of sentimental iconoclasm in my regard for Dowding, as there is in my insistence on using Imperial measure instead of the decimalized muck we all have forced upon us; & it is part of the same spirit in me which demands Cranmer's English, not institutionalized pablum, in the Book of Common Prayer, & refuses to see cholesterol as anything more than a medical bird scarer. A sturdy Anglican

common sense pervades this book. For example, here is Dowding in the Introduction to the original edition:

Keyboarding at 10,000 or more ens per hour is bound to result in appallingly bad composition, and an incentive system which encourages this by increasing the weekly wage packet in inverse ratio to the quality of the output, is not only pernicious, but, for the keyboard operator, utterly demoralizing.

I defy anyone to find, in any trade manual presently available and in regular use, any passage placing so moral a construct upon the excellence of work, let alone demonstrating a paternal regard for the soul of the worker. It might be said that we are well rid of such attitudes, but it seems to me the world is a more tight-lipped and stinting place for their loss.

The point which hovers all around Dowding's book, and is implicit in my attitude toward it, is that craftsmanship has been replaced by craft, efficacy by efficiency. This is not a new point: Shakespeare makes it in *As You Like It*, speaking of ' . . . the constant service of the antique world,/When service sweat for duty, not for meed', contrasting it with ' . . . the fashion of these times,/ Where none will sweat but for promotion.' It was, after all, William Morris's reason for starting the Kelmscott Press. My training as a compositor/printer was in hand-setting and handpress printing, and all the typesetting and much of the printing at Barbarian Press adheres to that tradition. It seems important to maintain a working knowledge of the fundamental crafts of book production, not as a sentimental archaism, but as a valuable concomitant to the technological explosion we are undergoing in the late twentieth century: implicit in Dowding is the sense that compositors and printers will, at some time, actually handle type; we are now given books made by the first generation of printers who have neither handled nor seen the stuff.

I am delighted to see Dowding back in print, & I applaud the de-

cision to make the book available to a new generation of compositors & typesetters. I confess to some unease about the updating of the text, not because this updating is not soundly considered and well done—it is. My unease springs from the ambivalence in my feelings about the book which I mentioned earlier: the sacrifice of generally outdated technical points might be said to alter the tone of the book, which depends for its moral quality partly on the work of the hand. But then my other self recognizes that Dowding, above all, intended his book to be useful, to be a manual; and that 'manual' can as readily mean 'at hand' as 'of the hand'. We need not lay aside any sense that morality & craftsmanship have a strong relation to one another.

I have re-read Dowding from cover to cover in the process of thinking about and writing this foreword. I am surprised again at both the fondness & the toughness of mind which the book evokes in me. I am, perhaps perversely, made aware of the historical nature of the work I do with type, & even more aware of my ignorance of much of the process by which this edition has been made. Dowding, I realize, is a teacher, & would welcome the opportunity to update and to make more useful the work of designing & printing a page: the three editions of the book printed during his lifetime attest to that. This new, updated edition of *Finer Points in the Spacing & Arrangement of Type* is welcome and useful, pleasing and instructive, as his book has always been. It will sit in the pressroom beside my original copy, and I will consult it for certain refinements I shall one day need to know. I may also find in it a means to block out the memory of the sound of case upon case of type being poured from a doorway into the efficient hell of a dump truck.

Crispin Elsted • Barbarian Press • March 1995

PREFACE TO THE 1966 EDITION

The notes on which this book is based were first used as material for teaching at the London College of Printing & they were written as much for the student-typographer who had decided on a career in the publishing world, as for those who wished eventually to design the typography of press advertisements & printed publicity of all kinds. 'There is,' wrote Stanley Morison, in his *First Principles of Typography* (Cambridge 1951) 'of course, a very great deal common to both book and advertisement composition.'

Neither a list of the parts of the book nor the basic principles relating to the design of the typography of press advertisements, booklets, or letterheadings have been included in the text: these the student will find elsewhere, for the necessary data has often been published. Instead, the text describes some of those details of setting which seem so often to be ignored or forgotten; details which may not be immediately obvious perhaps but which, in sum, add enormously to the appearance & the readability of text & displayed matter. These details govern not only the setting of the lectern Bible, but apply equally to the settings of eleven inch triple column advertisements, brochures, letterheadings, bills and bus tickets: that is, to all kinds of typographic work. Even the most carefully planned design will fall short of perfection unless unremitting attention is paid to these details, these minor canons which have governed both the written & printed manifestations of the Latin script from the earliest times. The first printers inherited what was, and had been for centuries, the accepted usage of the scribe: and the best of our contemporary printers adhere to this tradition for the eminently practical reason that its observance still produces the most readable and craftsmanlike work.

It is obvious that such a volume as this cannot be exhaustive, nor can it show within its compass many examples. But it is to be hoped that students will find in these notes a nucleus round which to build.

G.D. • September 1966

INTRODUCTION TO THE 1966 EDITION

How can consistently high standards of typography be achieved and maintained? Naturally much depends on the ability of the designer and on the technical accuracy of the layouts sent to the printer.[1] Nevertheless, perfection in design and technical accuracy in the marking of the layout for printer are only beginnings, for if the layout is sent to an indifferent printer then the resulting proof will look disappointingly unlike the pencilled plan.

A good printer, on the other hand, will produce an accurate representation of the layout sent to him, and will also attend with printerly pride to those details which make for good setting. Fortunately there are still some printing houses in this country where high standards of workmanship are maintained, but generally typesetting standards, both in composition and display, have fallen steadily for years. In fact, we seem, in some instances, to be reverting to the worst malpractices of the Victorian era. It is apposite here to quote from an article on COPY-FITTING by R. C. Elliott which appeared in *The Monotype Recorder* Volume 37 Number 2, 1938. He wrote: 'And this calls to mind the practice in book-printing establishments in premachine composition days, when the progress of composition had to be carefully watched to see that it was conforming to the estimated space. If the composition showed signs of making less than the estimated pages the compositors were told to *bump it out*; if it was exceeding the estimate instructions were given to space closely.'

These demoralizing practices, or the spirit engendered by them

[1] In the text of this 1993 edition, the word 'printer' has frequently been changed to 'typesetter', since the offices of printing and typesetting have become almost universally separated in the book publishing world. 'Fount' has been changed to 'font' throughout to reflect current spelling practice. [Ed.]

seem to persist, and the compositor in many printing estab-
lishments today has become a mechanic: he is no longer a crafts-
man. In extenuation it is often said that the compositor is a victim
of the machine age, but that is by no means the whole answer,
for mechanical composing machines intelligently handled by con-
scientious operators can undoubtedly be made to produce excel-
lent results, provided the emphasis, as so frequently appears to be
the case, is not entirely on *quantity* production. It is, of course,
true that the potentialities of our mechanical composing machines
have not been exploited as fully as they should in the direction of
quality production. But in the opposite direction there is, and al-
ways has been, abuse: the pernicious system of piece rates for the
job, for example, does not conduce to careful text setting & the
proper division of words, but only to a *maximum number of charac-
ters per hour* 'standard' and thus to disturbingly large amounts of
white space in the wrong places, i.e. between the words—the anti-
thesis of good composing & sound workmanship. Keyboarding at
10,000 or more characters per hour is bound to result in appall-
ingly bad composition, and an incentive system which encourages
this by increasing the weekly wage packet in inverse ratio to the
quality of the output, is not only pernicious, but, for the keyboard
operator, utterly demoralizing.

And typesetting standards will continue to decline unless the
typographer, who has taken over duties formerly the craftsman-
compositor's (the composition or arrangement of types as distinct
from the setting of them), is prepared to do constant battle for high
standards of design & of workmanship. The student-typographer
can help in this also, if, after the necessary preliminary training in
draughtsmanship and design he continues to perfect himself in
these, and at the same time schools himself to give full and *precise*
instructions to the printer. For example, if the measure in a setting
permits of optically even spacing between the capitals in a headline

then he must ask for that and not expect a visually spaced line if the layout or proof is marked *even spacing*.

Of course, the professional compositors & keyboard operators (both inside & outside the schools) whose job it is to train the apprentices to set type both by hand and mechanically could make a tremendous contribution to the establishment of higher standards simply by teaching their pupils how to set type properly—and by instilling into their impressionable minds first-rate standards of craftsmanship. For though many apprentices now receive design training from professionals during the years of their indenture, the time devoted to the subject in the course of a year is almost negligible. A few hours each week can never be a substitute for a normal full-time course in design: indeed, these brief excursions are likely to do more harm than good for they may give some apprentices the false notion that they can design with type—even before they are able to set it. And until an apprentice can do the latter properly design training will be to a large extent wasted.

But if the typesetting teachers and the unions concerned will make the contribution outlined above much will have been done towards rehabilitating the industry: much more than desultory studies in design by the apprentices or by their teachers are ever likely to accomplish.

A further step in this direction might be taken by giving apprentices a period of continuous instruction in the basic principles of design (under professional designers)—not with the object of producing embryo typographers but of helping them to understand the purpose of the typographer's work. A ready comprehension of the typographer's intentions would reduce corrections on proof and the mutual frustrations caused thereby and fine adjustments would no longer be regarded by the compositor as fiddling—as correction for the sake of correction—but as a means to one end: the production of first-class typography.

Bpus me facere cogis ꝗ
uercei:ut p̃ exemplaria
ſcripturaꝝ toto orbe diꝫ
ſperſa quaſi quidã arbit ſerea: ꝫ quia
inter ſe uariãt que ſint illa ꝗ cũ greca
conſentiant uericare decernam. Pius
labor ſed periculoſa preſumptio · indiꝫ
care de ceteris · ipſum ab omnibꝫ iudiꝫ
randũ: ſenis mutare linguã : et ſeneꝫ
ſcente mũdũ ad initia retrahere paruuꝫ
lorum. Quis eñ doctus pariter uel inꝫ
doctus cũ in manus uolumen aſſumꝫ
pſerit · et a ſaliua quã ſemel inbibit uiꝫ
derit diſcrepare qð lectitat · non ſtatim
erũpat in uoce me falſarũ me clamãſ
eſſe ſacrilegũ: ꝗ audeã aliquid in ueteꝫ
ribus libris addere · mutare · corrigeꝫ
re ꝫ Aduerſus quã inuidiam duplex
cauſa me conſolac: qð et tu qui ſumuſ

Part of a column of the magnificent 42-line Bible printed at Mainz circa 1455. It is reproduced same size. Notice the close and beautifully even word-spacing, achieved, despite the narrow measure, partly because numerous additional sorts were cut in order to make the pages of this Bible look as though they had been written by a scribe. A note on the treatment of the hyphens appears on page 34.

The Setting of Text Matter

By far the greater volume of type composition today is of matter for continuous reading, i.e. text. And so it has been since the day when printing from movable types was invented. For this reason the first part of this book has been devoted to an explanation of some of the fundamentals involved in the proper setting of body matter, viz. spacing between the words, the determination of the measure, or length of line, and the leading or spacing between the lines. Indications are then given showing how the principles which govern these vital factors are translated into day to day practice.

In beginning with text settings we are simply putting first things first. The setting of displayed matter forms a relatively small part—though, of course, it is a most important part—of the total volume of all composition. Displayed setting grew out of the treatment of the text page, & of the various needs of publisher, printer, and reader—and thus naturally follows the treatment of text setting. That the bulk of the latter is now produced mechanically either as hot metal or film is a further cogent reason for giving first place to it in this book.

melius nobis atq; beatius excogitari poteſt? Nōne uitæ:lucis:ueritatis
bonorumq; omniū ipſe fons atq; largitor eſt? Annon ipſe ut cuncta &
ſint & uiuant cauſam in ſe ipſo complectitur? qua ergo re indigebit q̄
eius amicicia adeptus eſt? qui rex omniū creatorē caritate ſibi cōiūxit?
qui patrem atq; tutorem illum ſibi aſcripſit? Non poſſumus profecto
dicere quin omnia quæ ad animam:quæ ad corpus:queq; ad externa
pertineant optime beatiſſimeq; is poſſideat:qui caritate proximus deo
factus:beatiſſimā eius amicicia exacta exquiſitaq; religione cōſecutus
eſt. Hanc ergo ſalutarem hominum ad deum conuerſionē atq; aīciciā
ab omnipotenti deo miſſus deus uerbum quaſi lucis iſinitæ ſplendor
cunctis annūciat. Non hinc aut alũnde:ſed undiq; cunctis ex gētibus
ad deum uerum:græcos ſimul et barbaros omnem ſexū: omnē ætatē:
diuites et pauperes:ſapientes et contra:līberos ac ſeruos magna uoce
cōuocat:hortaturq; omni ſtudio ac cura hoc donū ſuſcipiamus. Nam
ſicuti eiuſdem naturæ atq; ſubſtantiæ nos omnes creauit: ſic rurſum
cognitionem et caritatē ſuam æqualiter omnibus propoſuit qui grām
eius ex toto animo cōplectuntur et colunt. Hanc dei erga nos caritatē
Chriſtus qui ipſius dei patris uerbum eſt ipſe quoq; deus:nō reſpiciēs
ad peccata hominum:ſed ſe ipſū eis recōcilians uniuerſo ſicut diuina

Nicolas Jenson's roman type used in Eusebius, De Præparatione Evangelica, printed at Venice in 1470. This portion of a page, reproduced same size, illustrates how consistently close spacing between the words, and after the full points, secures one of the essentials of well set text matter—a striplike quality of line.

THE SPACING BETWEEN WORDS

From the time of the invention of printing from movable types in Europe, that is, *circa* 1440, up to the present day, one of the hallmarks of good printing, and of the good printer, has been the care and attention paid to the setting of text matter. An examination of the best work of the most famous printers since the mid-fifteenth century seems to indicate that one belief was held commonly, and adhered to consistently, by them all: they believed, as all good typesetters nowadays believe, that when words are set for continuous reading they should always be *closely* spaced and not en or em quadded!

But why has this practice been followed in all the best printing houses for over five hundred years? And why does this tradition survive in the liveliest of our contemporary printing establishments?

Up to the time of the invention of printing, writing had been the only means of recording men's thoughts & of multiplying the texts of books. The originators of movable metal types seem to have been alive to their opportunities for they were soon immersed in the very lucrative business of mass producing pages in imitation of the scribes' work. Naturally they based their types directly on contemporary manuscripts, which at that time & in that place were being written in a hand known to us now as the gothic or blackletter hand.

These first typefounders did their job thoroughly, reproducing in metal the scribes' multitudinous ligatures & contractions: further, in setting their types the early founder-printers faithfully reproduced the beautifully close spacing of the scribes' pages. The finishing of the printed texts, that is, their illumination, e.g. the drawing in of illuminated initials, marginal decorations and line finishings was completed by the illuminators. It is to the scribes, therefore, that we owe this tradition of close spacing in printing.

3

and lived deliciously with her, shall bewail her, and lament for her, when they shall see the smoke of her burning, standing afar off for the fear of her torment, saying, Alas, alas that great city Babylon, that mighty city! for in one hour is thy judgment come. And the merchants of the earth shall weep and mourn over her; for no man buyeth their merchandise any more: the merchandise of gold, and silver, and precious stones, and of pearls, and fine linen, and purple, and silk, and scarlet, and all thyine wood, and all manner vessels of ivory, and all manner vessels of most precious wood, and of brass, and iron, and marble, and cinnamon, and odours, and ointments, and frankincense, and wine, and oil, and fine flour, and wheat, and beasts, and sheep, and horses, and chariots, and slaves, and souls of men. And the fruits that thy soul lusted after

and lived deliciously with her, shall bewail her, & lament for her, when they shall see the smoke of her burning, standing afar off for the fear of her torment, saying, Alas, alas that great city Babylon, that mighty city! for in one hour is thy judgment come. And the merchants of the earth shall weep and mourn over her; for no man buyeth their merchandise any more: the merchandise of gold, and silver, and precious stones, & of pearls, and fine linen, and purple, and silk, and scarlet, and all thyine wood, and all manner vessels of ivory, and all manner vessels of most precious wood, and of brass, and iron, and marble, and cinnamon, and odours, and ointments, and frankincense, and wine, and oil, & fine flour, and wheat, & beasts, and sheep, and horses, and chariots, and slaves, and souls of men. And the fruits that thy soul lusted after are departed from

Both of these examples are in hand-set Monotype Bembo. The upper one is typical of much hand- and machine-setting seen today: an excessive amount of white space has been put between the words making reading harder. The first six lines are solid. The leading between the remaining seven naturally mitigates to some extent the effect of the carelessly word-spaced lines. But interlinear spacing is not to be misused in this way! When good type is properly set, as in the revised example, it is both a pleasure to read and a pleasure to look at. Note also that more than one complete line has been saved in the resetting, and the saved space has been used to good advantage in increasing the leading or interlinear spacing.

But to go back to our second question: Why has this tradition of close spacing (in the line) survived? There are at least two reasons. The first of them is an eminently practical one: it is an undoubted fact that lines and pages so set are easier to read than are pages with wide spacing between the words. Why is this so?

The child learns to read by spelling out words, at first letter by letter, then syllable by syllable and afterwards by reading individual words one at a time. But the eyes of the adult reader take in a group of words at each glance. And although quite wide spacing is desirable between the words of a child's book and ample leading also is necessary between the lines (though the word-spacing and the size of the type used in a primer for a five-year-old will be reduced progressively as the child grows older) it is unwise to allow compositors, in settings not intended for young children, to break the eye's track by introducing great gaps of white between the words.

Secondly, there is the aesthetic reason. The colour, or degree of blackness of a line is improved tremendously by close word-spacing. A carefully composed text page appears as an orderly series of *strips* of black separated by *horizontal* channels of white space. Conversely, in a slovenly setting the tendency is for the page to appear as a grey & muddled pattern of isolated spots, this effect being caused by the over-widely separated words. The normal, easy, left-to-right movement of the eye is slowed down simply because of this separation; further, the short letters and serifs are unable to discharge an important function—that of keeping the eye on 'the line'. The eye also tends to be confused by a feeling of *vertical* emphasis, that is, an up & down movement, induced by the relative isolation of the words & consequent insistence of the ascending and descending letters. This movement is further emphasized by those 'rivers' of white which are the inseparable & ugly accom-

5

more than a bit of patience always. Almost invariably to-day, the designer works far removed from the real field of action. More often than not, he has to deal with many different printers, and he will hardly ever know the men who actually carry out the work. If he has organized his job well, there will be a set of house rules in the hands of all who work for him, but, with the greatest care, such rules can never be exhaustive, and much will depend on his being lynx-eyed and uncompromising in enforcing the standards he has set himself.

The stresses and strains of the war and post-war years have resulted in a noticeable lowering of quality not only in materials, but also in workmanship. This is no less deplorable than it was inevitable, and should not be made an excuse for continued shoddiness and careless composition. If something of the old pride in their craft could be restored to the coming generation of compositors and pressmen; if we would learn something from the thorough system of training apprentices in Switzerland, for instance, and, formerly at least, in Germany, much would be gained. We could then take for granted many of the attributes of good setting and machining which at present can only be obtained by swimming very much against the current.

The sermon of careful letter-spacing has been preached often and by many. Its principles are not difficult to understand. In practice, however, this important matter is greatly neglected. Subtle adjustments are of the essence of good book design, and the need for them is not lessened by the fact that only one in a thousand eyes which

The above is a quotation from BOOK DESIGN TODAY, *an article by H. P. Schmoller in* Printing Review *No. LV, Spring 1951. It has been set by Linotype and Machinery Ltd in Linotype Pilgrim, 10pt on 12pt body. The following note accompanied this specimen: Extra thin spacebands were used, and normal care was taken to see that word spacing was reasonably even and close, by the judicious breaking of words at the ends of lines.*

paniments of all carelessly set text matter. The letter-spacing of words in upper- and lower-case, a practice often seen in jobbing work, increases the confusion. Of course, in solid, i.e. unleaded settings[1] such faults, both of word- and of letter-spacing, are especially noticeable. Some of these faults and the way in which improvements have been effected are to be seen in the examples on page 4. Opposite is a setting in Linotype Pilgrim.

Any feeling of vertical emphasis is absent in a well-composed page, the close word-spacing ensuring that the white space is available for use *between* the lines where it serves the useful purpose of aiding readability. It is astonishing how much space can be saved *depthwise* by close spacing in the lines themselves. Compare the examples on page 4. And in hand-setting when word-spacing in a line is close it is more likely to be even throughout the line. In varying the spacing between pairs of words in a too openly spaced line, frequently and often shockingly, the compositor is obviously not intent on securing visually even spacing throughout the line but on justifying it with the least amount of effort in the shortest possible time.

Some readers may think that we have been leaning too heavily on the work of the early printers in support of our case for good spacing within the line. We therefore append quotations from some late contemporaries and a contemporary:

Edward Johnston, in his classic, *Writing and Illuminating, and Lettering* wrote: 'The line—especially in MS. books—is really a more important unit than the page; & the whole question of the arrangement of Lettering hinges on the right treatment of the lines.

[1] Another point to watch in solid setting is the occasional widely word-spaced line in an otherwise closely spaced text setting. Open lines of this kind create the optical illusion of leading, and similar lines, even in a well-leaded setting, sometimes make it appear as though the compositor had slipped in an extra lead on either side of the line.

One is particularly struck by the distinctness of the lines of writing in the old MSS., due mainly to—
(a) The binding together of the letters in the line—commonly by strong serifs or heavy 'shoulders' and 'feet'.
(b) Packing the letters well together.
(c) Spacing the lines sufficiently apart.'
'Really fine writing shows generally to greater advantage if not too much crowded, and *there is more danger of making reading hard by crowding the lines, than by crowding the words*' (our italics).

That great printer, Sir Emery Walker, and co-partner with T.J. Cobden-Sanderson in founding the famous Doves Press at Hammersmith, once gave some advice to the typographer Bernard Newdigate. He said: 'The compositor's thick space boxes should be filled instead with thin.[1] The result is much closer spacing and freedom from those gaps and rivers which disfigure most modern printing.'

The publishers of Penguin Books, in the *Composition Rules* written for them by Jan Tschichold in 1948, gave these instructions to their typesetters: 'All text composition should be as closely word-spaced as possible. As a rule, the spacing should be about a middle space or the thickness of an 'i' in the type size used. Wide spaces should be strictly avoided. Words may be freely broken whenever necessary to avoid wide spacing, as breaking words is less harmful to the appearance of the page than too much space between words.'

It can, of course, be argued that word-spacing should vary with the type used, e.g. somewhat wider spacing (than the thin, or nearest equivalent space) might be used with a generously drawn face like Baskerville without its looking overspaced, than is necessary, or desirable, with condensed faces like Fournier or Blado, or other

[1] It will be remembered that a thin space is equal to one fifth of an em quad.

of the Chancery italics.[1] And it is held that similar modifications are helpful when the work to be set is poetry.[2] Wider word-spacing in verse, read as it is more slowly than prose, is not so objectionable or noticeable because poetry is often well-leaded, the verses have additional space between them and there is often ample white surrounding the settings—these, to a certain extent, offsetting the increased spacing between words. Some text types, if outprinted, i.e. reversed white on a black or coloured ground seem to need slightly more word-spacing than if printed normally. But whenever word-spacing is increased beyond the thin space care must be taken not to increase it to the point where the line ceases to be a unit.

From the foregoing it will be seen that this plea for closer word-spacing in text settings is not something which has been fathered recently by a small company of eccentrics. In the best printing it

[1] The first (Aldine) italic was followed by the beautiful and much more practical designs of Arrighi. These, and the fine hands of other sixteenth century writing masters have been used by our founders as models for what we know as chancery italics (*vide* Arrighi, Bembo, Bembo Condensed, Blado, Lutetia & Cancelleresca Bastarda among others). Today, alas, these beautiful types appear to be used almost invariably as space *wasters*. It is a common but absolutely illogical practice to widely word-space our most condensed italic types and to set them in line after unleaded line and occasionally in page after unleaded page! One sees them thus ill-used not only in ephemera but in the books of presses renowned for the correctness of their texts. Some of the care lavished on the discovery of literals should be devoted to the arrangement of the composition, for however beautifully a book may be bound or illustrated and however fine the paper and presswork may be the thing that makes or mars it above all others is the quality of its setting. In far too many books today the text type looks as though it had been slung together. Condensed faces need less, indeed, *demand* less, word-spacing than types of normal or wide set.

[2] 'The planner of the book of verse starts off by noticing—or deducing—that poetry is more concentrated than prose, and therefore has to be absorbed more slowly. The poet himself will have helped to counteract the habits of the eye set up by prose-writers, whose art it is to carry the reader straight forward. The verses will have been "paused" by white space even in the manuscript. But the poet cannot always follow his work into the composing room and suggest that leading be put between lines, and more than the normal space between words, as further ways of slowing down the reader.' Paul Beaujon in THE BOOK OF VERSE, a monograph in the *Monotype Recorder* Volume 35 Number 2 Summer 1936. This admirable essay should be read in its entirety.

has been an established practice for over five hundred years, and in the manuscript for many more centuries than that.

For the average run of work, it is frequently argued, good craftsmanship is too expensive a luxury: but when the largest publishers of cheap mass produced books of modern times (Penguin Books publish more than 25,000,000 volumes each year) instruct their typesetters in the manner described above, it is clear that good workmanship is not only a matter of sound sense, for the reasons already stated, but of sound economics also.

No valid reason has ever been advanced for slovenly typographic work: it cannot be excused on the score of cost.

* * *

In this age of computerized page make-up, control over wordspacing has never been so powerful or so neglected. Although previous generations of typesetters measured the em space in 18ths or 54ths of a unit, imagesetters and page make-up programs today allow the em space to be measured in thousandths of a unit if so desired. Such an exponential increase in units of placement allow the compositor a level of control never before experienced but is seldom needed to improve character-spacing unless the font is poorly designed.

A sixth of an em (m/6) is an appropriate minimum wordspacing for much of your text and you should aim for an average space band of a fifth of an em (m/5). However, with some faces (especially those widely cut) this will not be enough.

THE DETERMINATION OF THE MEASURE, OR LENGTH OF LINE

In arranging text setting care must be exercised to ensure that the type and the measure are so related that the eye has, firstly, no dif-

ficulty in swinging easily to & fro without any suggestion of strain: and secondly, is not hindered in finding the beginning of the following line.

'The length of the line', wrote J. H. Mason, in his essay on PRINTING in *Fifteen Craftsmen on their Crafts* 'has a minimum which admits of equal spacing as between line and line and a maximum of what can be read easily, although this ease may well be voluntarily sacrificed to scale and dignity. Given the principle, a certain latitude is freely admitted . . .' and the same writer in the second number of *The Imprint* said: 'Other things being equal, the longer the line the greater the excursions of the eyes and the greater the difficulty in passing from one line to the next. Very short lines, on the other hand, demand too frequent a change of direction in the movement of the eyes.'

If the matter is set solid—a readable measure for any well-designed *seriffed* face, is one of nine or ten average words,[1] as nearly as this is possible, i.e. a line of 54 to 60 letters and spaces.[2] But in the final decision it will probably be found that this generalization has been qualified by one or several of the following factors.

THE BODY-SIZE OF THE TYPE

Obviously in a solid setting this is a factor which largely determines the measure. As the body-size increases so the length of line

[1] An average word in English is counted as five letters plus the following space, that is, six characters in all. This number was based on calculations made from a leading article in *The Times*, an article in the same paper by H. G. Wells, and from a speech by George Bernard Shaw. But in making computations for medical, scientific, and legal work other averages apply. It is not unusual to meet single words, in medical publications and advertisements, which are of more than twenty letters, for example, electroencephalography. Long words occur frequently in legal and scientific literature also.

[2] The main text of this book is set in 10½/14 Ehrhardt. There are on an average 66 letters and spaces in each line. See *The measure*, under LEADING, page 15. Stanley Morison refers to 'the average line of 60 letters & spaces which was (the scribe) Poggio's favourite length'. See EARLY HUMANISTIC SCRIPT AND THE FIRST ROMAN TYPE. The Library, Fourth Series, Vol. XXIV, Nos. 1, 2. June, September 1943.

can be increased. Conversely, as it is reduced so the measure must be reduced.

THE X-HEIGHT OF THE LETTER

If the type is one with a large x-height[1] like Plantin 110 it will naturally set comfortably to a somewhat wider measure than will a face of small x-height like Perpetua. But in solid setting the latter face will be the more readable of the two because its long descenders keep the type lines apart, i.e. ensure a welcome separation of the lines.

THE 'SET' OF THE FACE

A round and generously formed letter like Baskerville can be set to a wider measure than a condensed face like Fournier.

THE DESIGN OF THE FACE

The best of those designs known as *old-face,* e.g. Bembo, 'Garamond', Caslon and some of the twentieth-century faces, e.g. Perpetua & Times permit greater latitude in the arrangement of suitable measures than do those type designs styled *modern.* In faces of this modern group (Bodoni, Walbaum, etc.), the extreme contrast between thick and thin strokes, and the weakness of their hairlines and unbracketed serifs tend to dazzle and tire the eye. Neither these, nor the sans serifs, are really suitable as designs for continuous reading, the latter because of the *absence* of serifs and the monotony of the (apparently) evenly weighted strokes. Even when short pieces of copy are set in faces belonging to either of these groups the greatest care must be exercised in arranging the set-

[1] The term x-height is used in describing lower-case letters only. It refers to the height of the short letters like a, c and e and the corresponding parts of the ascending and descending lower-case letters. The roman lower-case x was chosen because it lies between well-defined parallels.

tings—measures must not be too wide and the lines *must always be leaded generously* (see LEADING, below).

THE NATURE AND SCALE OF THE WORK

For what kind of setting are we designing? Is it a large work? How is it to be used? Is it for a Bible, a work of reference, or a novel? If the work is a lectern Bible the reader will be standing & his eyes will be at a considerable distance from the page: each period of reading is likely to be a short one. On the other hand if the work is a pocket dictionary or other book of reference it will either be consulted for brief periods or be pored over; if it is a novel it may be read quickly, perhaps in a single evening: an easily readable measure is therefore imperative.

* * *

For the treatment of text settings to narrow measures see page 38.

LEADING

Just as there are norms for word-spacing and rules for determining the measure in order to obtain settings of maximum readability, so certain principles have been formulated to guide us in leading lines of text matter.

Apart from the total area of the space available, the amount of leading in any given piece of text setting is usually decided by:

THE NATURE OF THE WORK

This governs to a large extent the conditions in which the text is read. Naturally the problem of the publisher, accustomed as he is to settings of great length, will be different from those of the designer of ephemeral printing (e.g. press advertisements) and from those of the jobbing printer.

Books for continuous reading and works of reference are normally leaded little, if at all, and this practice is one which has not changed since the early days of printing.[1] The reader of a book has either bought it, or taken it from a library shelf because he wants to read it. Given adherence to those principles which govern good book production the designer does not have to go out of his way to induce the buyer or borrower to read. Any undue separation of the lines is therefore unnecessary.

But in publicity printing of all kinds the possibly unwilling reader must be persuaded to read. For this reason it is unfortunate that so much of the text matter in this kind of printing is set in a slovenly manner, in dull, solid, or only slightly leaded, uninviting slabs, and often in the most unsuitable types. The copy in press advertisements needs to be well leaded if only to compensate in some degree for the conditions in which it is often read, i.e. in badly lit, swaying or jolting trains or buses. Certainly it should never be used as it frequently is used—as *pattern-making* material. When nine lines of 24pt Grotesque Light 126 are stretched, unleaded, across the full width (98 ems) of a *Times* page with over 100 characters & spaces in each line, the 'designer' of such a full-page advertisement could hardly have been concerned with getting the text read. Rather he seems to have been intent on using this large panel of light grey as a tint—a foil to the heavy caption and illustration which occupied the rest of the page!

One more example of this misuse of 'copy' comes from *The Guardian*. A full-page advertisement in that paper started off with a strong and interesting 4¾ × 5 inch halftone near the top of the page, centred over a 2-line caption in approximately 60pt Modern No 20 upper- and lower-case. Then came eight inches of white

[1] The relationship between the leading and the page margins must be watched for any increase in the former usually calls for more generous margination to offset it.

across the full width of the space. Below this, a four word sub-heading in 36pt Modern No 20 sitting on the first of three 25-em columns of 12pt Modern Extended (Series 7), set *solid.* These stretched their greyness unreadably across the page. Forty-one 25-em lines, 366 words of pattern-making material! This is to play at the serious business of designing press advertisements, to waste costly space and make a mockery of the art of typography.

THE BODY-SIZE OF THE TYPE

As the body-size of the type is increased (irrespective of the x-height of the particular face) it is reasonable to increase the leading proportionately also.

THE MEASURE

Those lines which exceed the normal, i.e. lines of more than nine or ten average words, *must* be leaded proportionately in order to compensate for the extension. If the leading is not increased as the measure is extended there is a risk of doubling, that is, of reading the beginning of the same line twice over. But some settings to very narrow measures may require less leading than those to normal or near normal measures.

THE X-HEIGHT OF THE FACE

Types of normal x-height like Bembo, Centaur, and Perpetua (i.e. faces with well-proportioned ascenders and descenders) will look well, and be extremely readable with considerably less leading than will types of large x-height like Times Roman[1] (Series 327) and Plantin 110, and, of course, those with abnormally large

[1] The use of the special long-descendered sorts g, j, p, q, y designed for use with Times Roman will in itself increase the whiting between the lines.

x-heights like the Ionics. In bookwork, faces like Imprint, Plantin 110 and Times Roman require, and are improved by, judicious leading. When such faces are used in press advertisements and jobbing printing a rough and ready guide for the leading of each point-size, with maximum readability in mind, might well be: 6pt (1½pt leading), 7pt (2pt leading), 8pt (3pt leading), 9pt (4pt leading), 10pt (4½pt leading), 11pt (5pt leading) and 12 and 14pt by perhaps half their bodies.

Additional leading may sometimes be gained in a setting by reducing the body-size of the type by one point (this small reduction is not, of course, always possible), the point so gained helping to make the matter more readable than it would have been in a more solid form.

THE DESIGN OF THE FACE

If matter has to be set solid, seriffed faces generally, with the exception of those styled 'modern', are undoubtedly easier to read than the sans serifs because the serifs help the normal horizontal movement of the eyes in reading by carrying them *along* the line. No such guides exist in a sans serif face and unless the lines are impeccably set and well separated by leading there is a distinct tendency to movement in the other direction, i.e. a vertical, or up-and-down movement.[1] Sans serif faces require more leading than any other kind of type, except perhaps the Egyptians. *Neither are suitable for solid setting.* Modern faces like Bodoni are inclined to dazzle the reader for the reasons already stated especially when printed on coated papers. Faces in this group should always be amply leaded.

[1] In a book for six-year-olds noticed recently, the text was set in 18 point Gill Sans to a measure of 32 ems (approximately nine average words to the line). An admirable size and measure it may be said: but not for a serifless face with only 3 points of leading! Three or four more points of spacing would have improved the readability of the book tremendously and obviated the risk of frequent 'doubling'.

THE WEIGHT OR COLOUR OF THE FACE

Apart altogether from the consideration of relative x-heights, faces which are light in colour[1] like Monotype Baskerville, Caslon and 'Garamond' need less leading than do the more colourfully weighted faces like Times Book.

In ephemeral printing the same rule applies, but the field is widened, for in many advertisements and in other forms of printed publicity bold & semi-bold faces are frequently used. Short pieces of copy set in types like Goudy Modern or Garamond Heavy can be admirably readable provided the lines are sufficiently leaded: 12pt Bodoni Heavy, for example, will comfortably carry leading equal to its body size.

SETTINGS IN MORE THAN ONE COLUMN

When text matter is arranged in two or three, or more, columns the width of the channel or channels of white between them must be related to the leading of the lines. The almost solid setting of a book will call for less space between the columns than a more generously leaded setting would do. With the latter there is a danger of reading *across* the inter-column whites if they are not sufficiently wide. The design of the type must also be considered, i.e. is it a type of large or small x-height? In ephemeral printing where two or more adjacent columns of text are set in the same size of type the leading should be identical in each column, the spacing of the headings, subheads, etc. being planned to make this possible. The positioning of individual lines will then correspond from column to column and a clean, and often much stronger, typographical pattern result. But frequently this consideration is ignored and in adjacent columns which have worked out with an unequal number of lines the columns are forced to align at head and foot by making

[1] *Colour* in this context means the degree of blackness of properly-inked and proofed type.

17

the leading dissimilar. This misuse of spacing material naturally results in muddled looking settings for though the first & last lines in each column align those between them do not. When text matter is arranged in double columns of the same width and the 'copy' in setting makes an uneven number of lines, a slight, and often unnoticeable increase or decrease in the measure of one of the columns provides a solution, by absorbing the odd line, or part of a line, or conversely, by providing a turn over.

<p style="text-align:center">* * *</p>

Designers who have noticed how an increase of leading (by as little even as one point) mitigates to some extent the slovenly appearance of a too-widely word-spaced setting should note that interlinear spacing is not to be misused in this way, or if so only as a last resort. For example, where work has been badly set and there is no time for the necessary resetting, a slight increase in interlinear spacing may make the job more readable and pleasanter to look at than it would otherwise have been.

PRINCIPLES INTO PRACTICE

So far we have discussed the general laws governing the setting of text matter. The following notes will show how these principles are translated into day to day practice.

BY THE DIVISION OF WORDS

Many books have been set without the division of a single word. But it is obvious that consistently close and even spacing cannot be achieved—except in the most unusual circumstances—if the typesetter has resolved *never* to divide words. Such works would rarely, if ever, be of any typographic distinction.

It is a popularly though erroneously held opinion that close

spacing in text setting inevitably *multiplies* the number of word divisions, for one can have as many, or more, divided words in a careless piece of text composition as in one that is well set. Indeed, the reduction of word-spacing in a slovenly setting often helps to reunite, and so reduce, the number of divided words. And in ease of reading we tend to gain more by the close spacing of words than we lose in the momentary pauses occasioned at the ends of lines by word-division: one pauses at the end of each line in any case.

The initial decision as to how words shall be broken is necessarily in the hands of the compositor or keyboard operator, but despite the manifest improvement which follows such practice many compositors and keyboard operators avoid dividing words either through a lack of knowledge of the rules involved or because the demand for *maximum-quantity* composition operates against the use of it. It is a most unfortunate fact that many apprentice compositors are still being taught that to have more than two successive break lines, i.e. lines ending with a divided word, is bad practice. This kind of training encourages the easy, slovenly solution: it is infinitely preferable to have a number of break lines succeeding each other than to have widely word-spaced lines. In a little book (*Symbola Heroica*) printed at Antwerp by Christopher Plantin in 1583 five successive hyphens are a commonplace, six occur frequently and there is at least one instance of ten. The word-spacing is very pleasant and there are never any rivers.

Readers may have perused *The Gift of Tongues* by Professor Margaret Schlauch, reproduced by Allen and Unwin Ltd in Great Britain from the original American setting. This book was reviewed by H. Jacob in *Printing Review* No. XLI, 1946. He wrote that it 'is set according to American principles of word division which, so far, are quite unacceptable to British publishers and printers [typesetters]... The words are not divided according to any ascertainable principles, they are neither broken according to syllables

nor according to etymological conventions [Eng-lish, unu-sual], *but merely to the convenience of a full line* (our italics). A secondary question arises which has always been of importance to publishers, the even spacing of every line. In the book referred to all lines are evenly spaced, white lines and rivulets through paragraphs do not exist. Regular and consistent word division has been sacrificed to obtain even spacing and far greater speed in composition, two distinct advantages.'

Though close spacing is necessary for the reasons we have already advanced, neither appearance nor increased machine speeds will ever justify breaking words *merely to the convenience of a full line.*[1]

Some other examples of word-division in Professor Schlauch's book are: unas-pirated, supernatu-ral, uni-ties, ema-nating, phonograph, multiordi-nal, spe-cial, ana-lytical, rep-resenting, processes, espe-cially, wo-man, us-ing, preoc-cupations, inevi-tably, sci-ence, colo-nists, jux-taposition, mo-notonous, au-thority, disasso-ciate, phenome-nology & proleta-rial. The second parts of compounds are frequently divided & authors' names have also been broken. The former practice is to be avoided because of the attendant, ugly, double hyphenation (neo-Egyp-tian). The division of authors' names, e.g. *Charles W. Le-land, Ad-ams'* should never be countenanced.

We have recently seen a wretched example of word division in

[1] 'It has certainly been the usual custom to aim at some sort of pattern in the division of the lines of type (in title-pages). In this respect the earlier printers [typesetters] had one advantage which was not enjoyed by their successors. They felt no difficulty about dividing a word in a title, even when the second part of the word was to be set in a different size or even a different kind of type. Frequently we find examples of such breaks in words as custom has made impossible for the modern printer [typesetter]'. A.F. JOHNSON in *100 Title-pages*. And at the Public Record Office in *Articles and Rules for the better Government of His Majesties Forces by Land, During the Present War* (1673) words can be seen in marginal sideheads which were broken to convenience as, Ar/med, ma/king, gi/ving, ta/king, a/ny, etc.

a handyman's magazine. A compound, *speed-grip*, was broken thus— *spee-* with the *d-grip* carried from the foot of one column to the top of the next! This mutilation could not even be defended as *breaking to the convenience of a full line* for the whole word could have been accommodated comfortably in the particular line. Another fault introduced by this arbitrary division was the ugly, unnecessary double hyphenation.

The rules for word-division are reasonably simple. F. Howard Collins in the preface to his *Authors' & Printers' Dictionary* wrote: Never separate a group of letters representing a single sound; and so divide a word that each part retains its present sound.... The case for the phonetic division of words has been so ably put by Professor Skeat that it is here added: 'The rule for the division of words is not the *rule of the root* by any means, but the rule of the sound or pronunciation. It is much best to ignore the root and go by the sound. Thus it is usual to make such divisions as are seen in impu-dence, solilo-quize, peru-sal, counte-nance, plea-sure... in perfect contempt of the root-forms, which are respectively pud-, loqu-, us-, ten-, plac-... We simply regard the utterance, writing pe-ruse at one moment and pe-ru-sal at another. Nothing is gained by pretending to keep the root intact, when the spoken utterance does nothing of the kind.'

Additionally, we should like to quote the printer and classical scholar, J. H. Mason, RDI,[1] on this subject: 'A correspondent from the Transvaal asks how we can justify such a division, as e.g. econ-omy. We are perfectly aware of the violence done to the etymological elements of the word, but eco-nomy, which is etymological, does phonetic violence to the English pronunciation of the syllables.

'Further, for a division meant for a reader—not for a listener— there is no need to adopt either principle. Much nonsense about

[1] *The Imprint*, April 17, 1913.

word division—and spelling too—is solemnly poured out by the quidnuncs and pundits of a trivial pedantry.

'Greek and Latin etymology is chiefly revered by those who know neither language outside the brief bracketed roots given in the English dictionary.Those who know most, care least about it!'

In Horace Hart's *Rules for Compositors and Readers* at the University Press, Oxford, we read: 'As a rule, divide a word after a vowel, turning over the consonant. In present participles take over *-ing,* as: carry-ing, divid-ing, crown-ing. Generally, whenever two consonants come together, put the hyphen between them: splendour, forget-ting, tetraphyl-lidea, haemor-rhage.'

And one should always try to divide so as to make the first part of the division suggest what is following. Oxford gives some examples: Starva-tion *not* star-vation. Re-adjust *not* read-just. Happiness *not* hap-piness. Ampli-fier *not* am-plifier.

It is, of course, always necessary to be on the alert for those divisions which are complete, and in the particular context, ludicrous words in themselves, e.g.

For a skin that's soft, smooth, and fresh as a camel-
lia petal, use regularly.

There are two places in which divided words prove objectionable. First, in books for the very young. Children who are learning to read are likely to be confused by them.The fact that a hyphen follows the first part of the division means little to a child. Second, no paragraph should end with a divided word. 'Widows'[1] are frowned on by some but much depends on their position on the

[1] A *widow* (the term used for a single word ending a paragraph, that is, on a line of its own) may affect design in jobbing work where the increased white resulting from such a short line might, in an advertisement space, unbalance the design. In bookwork such endings will always be preferable to those of the keyboard operators who, in order to avoid finishing with a 'widow', expand the word-spacing on the last four or five lines of the page or column.

page: syllabic 'widows' would rightly be condemned wherever they appeared.

BY THE USE OF THE AMPERSAND

In hand-composition the use of the short 'and', as this sign (&)[1] is sometimes called, is completely justified in all cases where the considerations of good setting demand it, that is, when the spacing of the line, and consequently of the panel, column, or page, is improved by its use.

By setting an ampersand in place of 'and' a little more than the width of a normal letter is saved, and this apparently small saving often makes it possible for another word or part of a word to be accommodated in the line. Frequently in ephemeral printing the use of an ampersand saves the copywriter from being asked to alter his copy in order to tighten the spacing of a gappily spaced line, or to avoid an awkward word division.

A corrector of the press writing in 1954 on the use of the short 'and' in text matter stated that 'The ampersand is not a character— it is a symbol.' He equated it with ∴ and + and ∵. Certainly it is a symbol for 'and', but in form it is *alphabetic* whereas the signs for *therefore, plus,* and *because* or *since* will never be! In the same article he said that ampersands '*look* out of place—in modern English text they *are* out of place.' But in venturing such an opinion he is at odds with the compilers of one of the source books of the English language—small though that volume may be. Readers who use the *Concise Oxford Dictionary* will know how frequently ampersands are used in its pages as space savers in narrow measures. That they are often set where there is space for 'and' is irrelevant in this con-

[1] John Southward wrote of the derivation of the name *ampersand* in Vol. 1 of *Practical Printing*: 'This was originally a ligature *&* (*et*, Latin for *and*), and when the alphabet was repeated rapidly the last character named was "*et per se, and*" (that is, et by itself, and), which became corrupted to "and per se and", and thence to "ampersand".' In many ampersand designs the separate letters E and T are easily distinguishable.

text. The point we wish to make here is that H. W. Fowler and F. G. Fowler obviously accepted these signs as normal means of communication—acceptable & intelligible not only to the learned but to ordinary users of their dictionary as well.

The judicious use of the short 'and' invariably improves the appearance and readability of a setting, but the (&) must always be used in a sensible and logical way. It invites criticism to set it in a line where there is sufficient space for 'and' (compositors often follow 'copy' too slavishly and insert an ampersand where 'and' would go): or to use it in conversational copy: or in the pages of a child's reader! It is preferable to set the contraction for *et cetera* as etc. and not &c.

The illustrative passages (right) are from Cardinal Newman's *The Idea of a University*. They are set in 12pt Perpetua, 1pt leaded. The widely word-spaced and consequently woolly appearance of the upper one has been greatly improved in the revision, an improvement which is impossible in this particular setting without the use of the single ampersand in the second line. Such reasonable usage of the short 'and' will only be opposed by the prejudiced: surely it is illogical to reject the use of the (&) in text setting and yet accept it as a (presumably) readily comprehensible sign in business titles.

It will have been observed that in some of the best type designs available today, for example Bembo, Granjon, Perpetua and Poliphilus, that the capitals are lower than the tops of the ascending letters and that the ampersands in these fonts are, again, *smaller* than the capitals. Consequently when ampersands are used in settings in any of these faces they do not over-emphasize their presence. But in other designs, e.g. Plantin 110 and Times Roman, the tops of the capitals, ascenders, and ampersands *are of the same height* and so the latter tend to look over-large and insistent.

In hand-composition, therefore, in these or any other designs

with similarly large ampersands, it is wise to set the (&) one or two point sizes smaller than the body matter of which it forms a part. Exceptions to this general rule might well be made where (a) the ampersand occurs within a capitalized phrase, and (b) when an ampersand comes between an ascending lower-case letter and a capital.

Occasionally the conjunction *and* occurs twice in a line in which it is necessary to save space. In such cases it is perfectly logical to contract the second of them only if this provides the space required. That we end up with what has been called 'two visual forms of the same word' appears to trouble a minority of readers but for most, I am sure, this fails to impede reading as gappily spaced lines certainly do.

It is called Logos; what does Logos mean? it stands both for *reason* and for *speech*, and it is difficult to say which it means more properly. It means both at once: why? because really they cannot be divided. . . .When we can separate light and illumination, life and motion, the convex and the concave of a curve, then will it be possible for thought to tread speech under foot and to hope to do without it—then will it be conceivable that the vigorous and fertile intellect should renounce its own double,

It is called Logos; what does Logos mean? it stands both for *reason* and for *speech*, & it is difficult to say which it means more properly. It means both at once: why? because really they cannot be divided. . . .When we can separate light and illumination, life and motion, the convex and the concave of a curve, then will it be possible for thought to tread speech under foot and to hope to do without it —then will it be conceivable that the vigorous and fertile intellect should renounce its own double, its instrument of expression and the channel of its speculations and emotions.

E MIE DEBILE VOCE TALE O GR A
tiofe & diue Nymphe abfone perueneráno &
inconcinealla uoftra benigna audiétia, quale
laterrifica raucitate del urinante Efacho al fua-
ue canto dela piangeuole Philomela. Nondi
meno uolendo io cum tuti gli mei exili cona-
ti del intellecto, & cum la mia paucula fufficié
tia di fatiffare alle uoftre piaceuole petitione,
non riftaro al potere. Lequale femota qualúque hefitatione epfe piu che
fi congruerebbe altronde, dignamente meritano piu uberrimo fluuio di
eloquentia, cum troppo piu rotunda elegantia & cum piu exornata poli
tura di pronútiato, che in me per alcuno pacto non fi troua, di cófeguire
il fuo gratiofo affecto. Ma a uui Celibe Nymphe & admealquáto, quan
túche & confufa & incomptaméte fringultiéte haro in qualche portiun-
cula gratificato affai. Quando uoluntarofa & diuota a gli defii uoftri &
poftulato me preftaro piu prefto cum lanimo nó mediocre prompto hu-
mile parendo, che cum enucleata terfa, & uenufta eloquentia placédo. La
prifca dunque & ueterrima geneologia, & profapia, & il fatale mio amore
garrulando ordire. Onde gia effendo nel uoftro uenerando conuentuale
con fpecto, & uederme fterile & ieiuna di eloquio & ad tanto preftáte & di
uo ceto di uui O Nymphe fedule famularie dil accefo cupidine. Et itan-
to benigno & delecteuole & facro fito, di fincere aure & florigeri fpirami-
ni afflato. Io acconciamente compulfa di affumere uno uenerabile aufo,
& tranquillo timore de dire. Dunque auante il tuto uenia date, o belliffi-
me & beatiffime Nymphe a quefto mio blacterare & agli femelli & terri-
geni, & pufilluli Conati, fi aduene che in alchuna párte io incautamente

A

It should be remembered that while the (&) looks quite happy at
the beginning of a line it may not do so at the extreme end of a line,
or preceding a comma.

Precedents for the employment of the ampersand in text matter
there are in abundance for it has been the custom of the best print-
ers since the fifteenth century to use these readily intelligible
signs. In his *An Essay on Typography* Eric Gill wrote that 'it would

be a good thing typographically if, without any reliance upon medieval or incunabulist precedent, modern printers [typesetters] allowed a more frequent use of contractions. The absurd rule that the ampersand (&) should only be used in 'business titles' must be rescinded, and there are many other contractions which a sane typography should encourage.'

As an illustration of the use of ampersands by early printers we show part of a page (opposite) from Francesco Colonna's *Hypnerotomachia Poliphili* printed by Aldus Manutius at Venice in 1499. In this superb piece of text setting the printer has used twenty-five ampersands: it will be noticed that four have been used in one line alone, but despite the frequency of their occurrence throughout the book these signs do not obtrude themselves. The line length in the original is a fraction over $31\frac{1}{2}$ ems.

Why did the early printers use the ampersand? This is a problem that has long intrigued scholars. Certainly it was not as a space saver for the sign in pages set in Italian is much wider than the single character (e) for which it is substituted and even in Latin occupies much the same width as the two letters it represents in that language. Mr. George D. Painter of the British Museum's Department of Printed Books whose views I sought on this matter wrote: 'This is an interesting but highly subjective problem, involving as it does not only twentieth but fifteenth century matters of taste! I can only give my own equally subjective impressions. I would agree with you and Paul Standard that the use of the ampersand was primarily aesthetic and traditional, and only secondarily utilitarian (i.e. as a space saver). It is or can be a beautiful object in its own right, and was dwelt upon more lovingly by scribes and type-designers than any other sort except Qu, I should say. It was adopted in fifteenth century printing not only because type was designed from manuscript models but because compositors were affected by manuscript traditions, not only in a general way but of-

Instruction is given in throwing, turning, modelling & mould-making, pressing & casting, jigger & jolley work; hand-building methods, tile-making, pottery sculpture. Decoration including the use of slips, glazes & colours. Painting both under & over the glaze. Students learn the composition & application of various kinds of glaze and how to pack and fire both high & low temperature kilns. Class lectures on simple Pottery Chemistry, on design and on the appreciation of pottery.

Books on typography & its related arts & crafts may be divided into many categories, but attention is here drawn to the kind of book which is mainly a collection of reproductions of printed pages or illustrations, with little or no commentary, & that kind which is largely in words, with little or no illustration. Both kinds are valuable. Broadly speaking, knowledge once acquired & practised is acquired for good, & books which give only technical knowledge of the craft tend to be consulted less and less as time goes on. On the other hand, collections of first-rate examples of typographic design remain an inspiration & a pleasure even to the expert. Where the student can afford to buy for himself some of these books he will rarely regret purchasing those which are largely illustrations of fine typographical design. At the same time, a full understanding of type & its use cannot be acquired without considerable reading, & on the next page is a list, with commentary, of some of the best books I have read

The first example, from the prospectus of a school once famous internationally for its teaching of typography, shows five instances of misuse of the ampersand in its first six lines! Only two were needed. The twenty-five text pages were riddled with similar examples including the use of the & in the final, short, lines of paragraphs. The Times Roman ampersand is not one to be used, even properly, in text setting in font size: it is too large and therefore spotty and insistent.

The second example, specially set for an article (IN DEFENCE OF THE AMPERSAND) to demonstrate 'the application of the & in the very best way' made a mockery of the author's appeal for a sensible use of the ampersand. Six of these were unnecessary!

ten under the influence of the particular manuscript which they happened to be setting. Any particular instance would be difficult to diagnose owing to the numerous imponderables, such as the master printer's or foreman's instructions, the compositor's own preferences or mood, the supply of type in his case at that time, or the influence of the manuscript he was setting from. But in general I feel sure he would think a good page demanded a few ampersands for their own sake.

'I rather doubt whether the ampersand *was* used as a space saver in most types, as it would take up the same or almost the same space as the *et* from which of course it is derived, and the repertoire of possible space-saving contractions was so enormous without it.'

BY CLOSE SPACING AFTER FULL POINTS AND
BEFORE AND AFTER OTHER MARKS OF PUNCTUATION

Frequently an unnecessarily large amount of space is inserted either before or after—and sometimes on both sides of—marks of punctuation. For instance, it is customary to find far too much space *after* full points in text settings of all kinds. In some houses an en or em quad seems to be the rule. If the spacing after each point approximates to that of the remainder of the setting it will be ample. *No* space is necessary after the full point when it is followed by the capitals A, J, T, V, W, and Y. The only occasion on which more than the normal text spacing after a full point could possibly be justified is when the spacing between the rest of the words in the line would have to be opened too widely to make a good line if such an increase were not made. Sometimes a slight adjustment like this may save a short line from appearing too gappily spaced.

Colons and semi-colons are often carelessly spaced also. Only a hair space is necessary *before* them, that is, between them and the words they follow, and this can be omitted if the letter preceding

the colon or semicolon happens to be f, k, r, t, v, w, x, y, or z. No more than the normal text spacing should be inserted *after* these two marks of punctuation.

Not this way : A verb and its subject ; as, *Time flies.*
But like this: A verb and its subject; as, *Time flies.*

'Exclamation and interrogation points should if possible be set off with thin spaces because they often form disagreeable and confusing combinations with the last letter of the word, such as ff!, ll!, f?, etc.'[1]

BY THE RIGHT TREATMENT OF QUOTATION MARKS

The use of quotation marks *never* improves text settings. Whenever the meaning is clear without them they should be omitted (*vide* the setting of The Bible, The Book of Common Prayer and of plays). If their absence is likely to cause confusion then use *single* quotes only, *never* double ones, except when a quotation appears within a quotation. Then commence with single, & open and close the second quotation with double quotes. If there is a third quotation within the second then enclose it in *single* quotes. Double quotation marks introduce an excessive amount of white into the lines (see Ex. 1, below) however carefully they are set and so destroy the even colour of the lines, and, if there are many of them, of the page.[2]

1 In combating "deficiency diseases" in plants and animals
2 In combating 'deficiency diseases' in plants and animals
3 In combating'deficiency diseases'in plants and animals

[1] Bruce Rogers in *Paragraphs on Printing.*
[2] 'Quotations become more telling if isolated by white lines, and quotation marks, which are fidgety, may by this means often be dispensed with. Such isolation is a far more logical treatment than the irritating inverted commas and apostrophes', wrote J. H. Mason in an essay on PRINTING in *Fifteen Craftsmen on their Crafts,* Sylvan Press.

4 'Secondly, when the arrangement of the setting permits quotation marks at the beginnings or at the extreme ends of lines should be set *outside* the measure, i.e. as with this example'

When one has no option but to use quotation marks the spotty effect which they create can be minimized in the following ways:

Quotation marks should *always* be set close to the words they enclose, i.e. not more than a hair space should be used after the opening one and this hair space can be omitted before certain capitals, e.g. A, C, G, J, the 'd', and the non-ascending and the descending lower-case letters. Treat the closing quotation mark similarly, unless it encloses a point or a comma, when the hair space should be omitted. The usually excessive spacing put in *before* an opening quote, and *after* a closing quote should be so reduced that the word-spacing before and after the quoted word or sentence appears to be the same as that in the rest of the line. See Ex. 2 and 3, above.

When quotation marks are used see that the first, or turned comma, is raised so that it appears to align with the closing quotation mark. See Ex. 3, above. This adjustment improves the quality of the setting but is not necessary in all fonts, e.g. certain Linotype faces have *matched* quotation marks.

Secondly, when the arrangement of the setting permits, quotation marks occurring at the beginnings, or at the extreme ends of lines, should be set *outside* the measure, that is, overhanging the page or column of type on the left or on the right. See Ex. 4, above. Treated in this way the untidy indentions produced by setting quotation marks in the usual manner are avoided, & a much pleasanter looking setting results.[1] It should of course be remembered

[1] An example of this traditional way of dealing with these disturbers of good spacing occurs in the preface to Vol. I of Christopher Plantin's famous Polyglot Bible, a work in five volumes printed between 1569-1573.

that overhanging such marks increases the measure *throughout* the work being set.

In settings where the first lines of the paragraphs are *not* indented treat the marks in paragraphs *commencing* with a quotation in the manner described above, i.e. let the quotes overhang on the left. But if a paragraph commences with a quotation in a setting in which the first lines are indented then the indention for that particular paragraph *must be reduced* to compensate for the extra white introduced by the quotation mark. For an example of this kind of treatment see page 11.

If the title of a book, play or film occurs in a line it should not be enclosed in quotation marks but set in italic upper- & lower-case or in letter-spaced small capitals. There are examples of this kind of treatment in this book.

And it is well to avoid the use of ditto marks which are unsightly either by repeating the word or words, or by setting a single covering word or phrase above the word or words which have to be repeated. In a list of type faces noticed recently ditto marks had been omitted but in place of them appeared nearly forty repetitions of do. do.! Each untidy pair of abbreviated dittos represented four simple words, namely *upper- and lower-case.*

An exception to this rule for close spacing before or after marks of punctuation must be made when apostrophes are used in some fonts as in the following line for example: 'Fournier's italic shows not only a considerable differentiation......' Fractionally more than the normal word-spacing is required after the 's to prevent that letter from appearing to attach itself to the next word.

BY THE OMISSION OF UNNECESSARY PUNCTUATION MARKS

The introduction of unnecessary punctuation marks and their frequently careless setting makes for fussy and ugly typography. All typescripts or manuscripts should be carefully looked through be-

fore they are sent to be typeset; indeed, even the briefest piece of copy must be examined and unnecessary marks of punctuation deleted. Deletions on proof and consequent spacing adjustments can quickly add up into large resetting charges. By examining and marking all copy before it is sent to the typesetter one achieves a cleaner first proof at less cost and in less time.

A few examples of the kinds of punctuation which are so often set but should be omitted are given below.

The full point can well be omitted after the following abbreviations: Mr, Mrs, Messrs, Dr, St, Co, 4to, 1st, and Ltd; and after the contractions am (ante meridiem), depending on the context, and pm (post meridiem) and between postal letters and numbers, e.g. SW1. It should be omitted after the abbreviations of county names, e.g. Beds, Wilts, and after roman numerals (MCMXXV) except when such numerals come at the end of a sentence.

Name and address lines of publishers on the title pages of books, and of manufacturers in their advertisements and other forms of printed publicity, are notorious for over-punctuation. Try closely word-spacing such lines and setting them without any kind of punctuation whatsoever and notice what a pleasant result the omission of points and commas gives. When punctuation has to be inserted in these lines full points can be used to divide the parts of the line instead of the customary commas. Points are less fussy, but they must be centred on the depth of the face of the capitals if the lines are in capitals, and on the x-height if the lines are in upper- and lower-case, and of course they must harmonize in weight with the face used.

The comma. A comma is required before, but not after, e.g. and i.e.

The apostrophe. No apostrophe is required in the plural forms of such contractions as M.A.s, the 1920s.

Most major book publishing companies have a 'House Style'

33

manual. These will repay study. The bibliography on page 84 also lists several references on style. Where conflicting advice on omission is given the marks of punctuation should in all cases be left out if the meaning is not in any way confused thereby.

<div align="center">BY THE CAREFUL SETTING OF HYPHENS,
DASHES, PARENTHESES AND BRACKETS</div>

Hyphens are normally designed to centre on the x-lines of the fonts they are supplied with—that is, on the centre of the face of the small (or short) lower-case letters like a, c, and e. When they are used with the capitals of the font they appear to be dropping—attempting to find a resting place on the 'line'. Nicolas Cochin can hardly be counted as a text face, but it will serve as an extreme example of this hyphen slipping because of its small x-height and the exaggerated height of its capitals and ascenders.

Faults like this, originating in a lack of material, will in time, one hopes, be remedied by the typefounders. An additional hyphen for each body-size designed to centre *on the face of the capitals*, is all that is needed. But until these are available typesetters should be asked to raise hyphens when they are used between, or with, capitals so that they centre on the depth of the face. See Ex. 1 and Ex. 2 below.

In narrow measure settings one often sees a ragged hyphen rash on the right-hand side of the column engendered by an insistence on squaring the measure on both sides. Such treatment usually entails the over-frequent division of words and the consequent

1 *Not this way*: TITLE-PAGE
2 *But like this*: TITLE-PAGE

3 This en rule – misused as a dash is too short and appears to be floating.
4 This em rule—is correct and is properly spaced. It looks much better.

5 *Not this way with* (PARENTHESES) *or* [BRACKETS]
6 *But raised, so*: (PARENTHESES) & [BRACKETS]

appearance of far too many hyphens. These are unsightly, especially in the left-hand columns of double column pages. In settings where such raggedness is likely to occur the hyphens should always be set *outside* the measure—a perfectly simple procedure for the hot metal compositor but a feature of only the most sophisticated page make-up programs.

This method of setting hyphens was practised by the early printers particularly in their double-columned pages. For example, in the 42-line Bible printed at Mainz *circa* 1455, a very pleasant double-diagonal stroke hyphen is used *overhanging the columns*. See the page facing page 1. Full points are treated in the same manner in this Bible. Occasionally, overhanging a hyphen, comma or full point gives one the fraction of space which saves a short line from being too closely spaced.

There is sometimes a tendency to insert hyphens where they are not needed. In case of doubt as to when, or when not, to use the hyphen, refer to *The King's English* for a short account or *Modern English Usage* for a longer account.

Dashes, like hyphens, are designed to centre on the face of the small or lower-case letters only. Fortunately they are unlikely to occur frequently, but when they do, and when they are set with the capitals of the font, they must be raised to centre on the depth of the face of the capitals in the manner described under HYPHENS above. Again, the founders can remedy this deficiency in their fonts.

When dashes fall at the ends of lines they look better on the *right* rather than at the beginning of the line for when they occur at the beginning they make the line appear indented. Especially ugly shapes are created when this false indention occurs on the second line of an already indented paragraph. And dashes too can overhang, i.e. be set outside the text measure. Only in publicity work, where the setting may be designed with an uneven left-hand edge

and a squared right-hand edge, should dashes be allowed to fall at the beginnings of the lines.

Readers may like to refer to G. V. Carey's *Mind the Stop, A Brief Guide to Punctuation* (C.U.P) 1948, pp. 69–73. In this informative work the author not only gives a number of examples of 'perfectly legitimate and entirely appropriate' uses of the dash or em rule but also shows how it should be set. As a recognized mark of punctuation it is part of all properly constituted fonts. *En* rules are rightly used in a sequence of figures, e.g. pp. 9–10 but they should never be used as substitutes for dashes because the tendency, then, is for them to look like misplaced hyphens, or minus signs. It is possible that this malpractice—the use of this bastard dash—has grown from a slavish following of typescript copy. Most typewriters are equipped with a hyphen only and when a writer indicates that he requires a dash the typist is forced to use the hyphen with a space equivalent to the width of a letter on either side of it! Dashes should be separated from the word or words they relate to by a hair space only.[1] If too much space is inserted on either side of them they appear to be floating, and the line becomes too gappy. See Ex. 3 and Ex. 4, p. 34. Dashes should not be used for separating the items in itemized copy. No less than fourteen were used in this manner in four lines of 10pt Times italic upper- and lower-case set to 24 ems! They appeared under the caption of an advertisement. Centred points would have taken up less space and would have improved the appearance of the setting immensely.

Finally, it is as unnecessary as it is ugly to use the dash preceded by a colon so:—. Use either the one or the other mark of punctuation. Do not use them together.

Parentheses and brackets. Both marks of parenthesis () and brack-

[1] Quite often one or both of the hair spaces can be omitted because the letter preceding and/or that following the dash makes its own white. For example no hair spaces were necessary either before or after the dashes in line 12, above.

ets [] look perfectly satisfactory when enclosing matter set in up-per- and lower-case but appear to have dropped if they are used with capitals. The typesetter should therefore be asked to lift and centre them on the depth of the face whenever they are used with capitals. See Ex. 5 and Ex. 6, p. 34. When a mark of parenthesis or a bracket falls at the beginning or end of a line (in a squared-up setting) it makes the line look as though it had been indented. In such cases the mark of parenthesis or the bracket should be set outside the measure.

BY THE USE OF LIGATURES AND LOGOTYPES

The term ligature comes from the Latin word 'ligatura' which means anything used in binding or tying. In printing, an exact defi-nition of the word would recognize only the *actual* tie or link be-tween two joined letters, e.g. between the letters *ct, st* in some fonts. Now, however, the term ligature is used less exactly to de-scribe those combinations of either two or three letters which are *joined* together and cast as one unit, for example, ff fi fl ffi ffl, and the compound vowel characters, or vowel-ligatures, æ, œ, known as diphthongs. The 'f' ligatures & the vowel-ligatures are the ones which are standard to the normal font.

1 *Not this way*:　He fled through the fields
2 *But like this*:　He fled through the fields
3 *Not this way*:　C o ff e e i s s e r v e d
4 *But like this*:　C o ff e e i s s e r v e d

The early founder-printers cut multitudinous ligatures for their fonts: today, only certain type designs, e.g. Caslon Old Face and 'Garamond' carry (in roman and italic) great numbers of ligatured letters. See page 72.

By some writers the word *ligature* and the word *logotype* are treated incorrectly as synonymous for the latter is derived from the Greek *logos* meaning 'word' plus the word 'type'. Many logotypes

are, in fact, complete words, but usually, they are two, three, or four letter combinations which are *not* tied or linked together in any way and so cannot be called ligatures. But why mention ligatures and logotypes?

If letters, normally ligatured, are set separately, as they sometimes are, they create the impression that they are on the wrong 'set'. See Ex. 1 and Ex. 2, above. This unpacked and spotty appearance is caused by the excess of white space round them.[1] From the purely practical point of view ligatures are space savers[2] and some logotypes take up less space than the individual characters do.

Certain characters, set as individual units adjacent to each other look most uncomfortable, e.g. the *gg* and *gy* of Monotype Garamond Heavy and the *gy* of Monotype Perpetua italic. The Monotype Corporation have cut double character matrices for use in these cases: *gg gy* and *gy*.

<div align="center">

BY THE LOGICAL TREATMENT

OF NARROW MEASURE SETTINGS

</div>

Narrow measures, that is, lines of four or five average words or less have always militated against good setting. Very occasionally the disposition and simplicity of the words, combined with the skill of the compositor, make for an excellent setting in a really narrow measure. But such settings are exceptional. Conversely, examples of those cramped, difficult-to-read and patchily-coloured settings confront us daily, not only in newspapers and other ephemeral printed matter of all kinds, but also in publishers' illustrated books. In these settings the spacing between the words is excessively wide in many, if not most, lines, while in others it is non-

[1] But normally ligatured characters like ff, fi *must* be set separately when they occur in *letter-spaced* lines of upper- and lower-case. See Examples 3 and 4 above.
[2] The use of ligatures often confuses the child who is beginning to read.

existent. Frequently the line filling capacity of the words has been eked out with letter-spacing[1] in order to make lines square with their neighbours. In narrow measures word breaks are liable to occur frequently & these cause a ragged hyphen rash and ugly linear irregularity on the right-hand side of the column.

How can the typographer overcome this oft-recurring problem of the cramped measure? Of course, one should never use a larger size of type in a narrow measure than is necessary for easy readability. Sometimes the answer lies in a slight increase of the measure. But a more radical and logical approach is to free the column from its rigid squared-up shape by setting it with an uneven right-hand (or left-hand) edge. See examples, page 41.

Occasionally a very free arrangement with uneven edges on both the left and the right may be appropriate.

In this kind of setting, that is, where one or more edges are free, there are certain definite and immense advantages. The same word-spacing can be used throughout except before or after certain letters.[2] The justification of each line is a much simpler matter

[1] The letter-spacing of lines weakens them in colour, i.e. degree of blackness. If it has to be done in ephemeral printing to mitigate the effect of excessive word-spacing then it must be done evenly throughout the line and adequate separation between the words must be maintained. But even the most careful letter-spacing weakens not only the line, but the colour of the remainder of the setting.

[2] In the finest hand composition the spacing is so varied between the words when each line is being justified as to secure visually even word-spacing in the line. For example, besides the capitals, the shapes of lower-case letters, like v and w, are taken into account and less space inserted before or after them depending on whether they commence, or end, a word. In some fonts the word-spacing after an apostrophe seems to need increasing fractionally to give the appearance of visually even spacing in the particular line.

And it is apposite to add here that if one is seeking space in a line which contains odd capitals one can reduce the spacing before or after such capitals. Similarly the spacing may be reduced between a capital and some ascending letters. And if a line contains, as most lines do, ascending lower-case letters, the space may be reduced before or after those letters. The danger of the words running together is minimized in the first and second cases by the height and bulk of the capitals, and in the latter by the stems of the ascenders.

and setting costs are reduced. But one thing must be watched in these settings where one or both edges are uneven: the breaking up of the text. Ideally, each line in a narrow measure setting should be divided as far as possible by sense, i.e. each break in the structure of the sentence being as rounded off as conditions and matter will allow: in an American work, *Typographic Directions*, published in 1964 such breaking was referred to as *cadencing.* The ending of lines with conjunctions or with the definite or indefinite article should be avoided if possible, and further, the division of words in uneven-edged settings can, and should, be reduced to a minimum. If such settings are used within a border careful consideration must be given to the choice of the surround for within a very rigid shape they can look completely out of place.

This method of setting[1] is one that should *always* be used in arranging the narrow columns of indexes and even when such columns are set to measures which cannot be considered particularly narrow in relation to the body-size of the type employed, setting with an uneven right-hand edge improves the appearance of these pages enormously and therefore their capacity for being easily used and read. Far too many scholarly works suffer spotty, undistinguished endings because of the publisher's insistence on squaring up these columns.

Excellent examples of apparently-unjustified setting are appearing in our newspapers. It is a trend that one hopes will grow.

[1] The term *unjustified* has unfortunately been widely used in describing this style of setting. It sounds well but is a misnomer. For obvious reasons no type line—either hand- or machine-set—is ever unjustified. In the first and second editions of this book we used the term 'ragged-edged' to describe this kind of setting but while not a misnomer in the sense that *unjustified* is, and although it accurately describes the product of many compositors when asked for settings with one or other of the edges freed, it may mislead them for it also describes precisely what typographers do *not* want. Might not the description *apparently-unjustified* replace both of these misleading terms?

Conversely, examples of those difficult-to-read, patchily-coloured, narrow measure settings confront us daily, not only in newspapers and other ephemeral printed matter of all kinds, but also in publishers' illustrated books. In these settings the spacing between words is excessively wide in many, if not most, lines, while in others it is non-existent. Frequently the line filling capacity of the words has been eked out with letter-spacing in order to make lines square with their neighbours. In narrow measures word breaks are liable to occur frequently and these cause a ragged hyphen-rash and ugly linear irregularity on the right-hand side of the column.

How can the typographer overcome this problem of the cramped measure? Of course, one should never use a larger size of type in a narrow measure than is

Conversely, examples of those difficult-to-read, patchily-coloured, narrow measure settings confront us daily, not only in newspapers and other ephemeral printed matter of all kinds, but also in publishers' illustrated books. In these settings the spacing between words is excessively wide in many, if not most, lines, while in others it is non-existent. Frequently the line filling capacity of the words has been eked out with letter-spacing in order to make lines square with their neighbours. In narrow measures word breaks are liable to occur frequently and these cause a ragged hyphen-rash and ugly linear irregularity on the right-hand side of the column.

How can the typographer overcome this problem of the cramped measure? Of course, one should never use a larger size of type in a narrow measure than is necessary

Besides the gross imperfections of word- and letter-spacing and the distinct tendency to a vertical *pattern and eye movement in the left-hand column there are eight unnecessarily divided words! In the revised setting of the same copy on the right each line has been thin word-spaced and while breaking the lines by sense has not always been possible, the appearance, colour, and what is even more important, the readability of the text have been immensely improved. Despite its freed edge this setting does not occupy any more space depthwise.*

It is obvious that, with letters of different widths and words of different lengths, it is not possible to get a uniform length in all the lines of words on a page. But by sacrificing even spacing between letters and words short lines can be made to fill out to the same length as long ones. When the measure, i.e. the width of a page, is very wide in proportion to the size of type to be used, the sacrifice of even spacing is not noticeable; on the other hand when the measure is very narrow unevenness of spacing becomes obvious. Now uneven spacing is in itself objectionable—more objectionable than uneven length of lines, which is not in itself objectionable. We make no objection to uneven length of lines in blank verse or in a handwritten or typewritten letter. On the other hand, uneven length of line in a page of prose is not

*　　*　　*

'If you intend to design books in all their elements, then you should make a close study of papers, not necessarily of the actual processes of their manufacture, for the better paper-makers of today may be trusted to furnish you any kind of sheet you want; but rather you should study the printing qualities of different papers and the adaptation of suitable papers to the types you are about to use. Paper is one of the finest products man has ever invented. The first books I remember to have seen on hand-made paper, while typographically of no interest, seemed very attractive to me. So much emphasis has recently been put on type that the question of paper, which to my mind is even more important in bookmaking, has been somewhat neglected.'

In the first setting are some examples of shapings which should not be countenanced if it is possible to avoid them. The paragraph opens with unsupported lines and this weak start is followed by some of that fussily distracting 'ragging' that draws too much attention to itself. The quotation is from Eric Gill's An Essay on Typography. *The second example, a quotation from Bruce Rogers'* Paragraphs on Printing, *shows the kind of gentle unevenness one should try to achieve in apparently-unjustified settings.*

APPARENTLY-UNJUSTIFIED SETTINGS TO NORMAL MEASURES

In the first edition of this book we wrote: 'Occasionally, even when setting to *normal* measures, an instruction to the printer [typesetter] to set with thin or middle word-spacing (or their nearest equivalents) throughout and allow one or other of the edges of the text-mass to end unevenly is one way of ensuring high quality in the resultant setting although the work may be handled by an indifferent printer [typesetter]', & later 'The setting of pages in this manner solves one of the greatest problems facing any competent designer of books—that of obtaining close word-spacing throughout the text...But it raises other problems...' which have been met in setting considerably varied work to normal but *apparently-unjustified* measures.

First, the irregularity of the uneven edge must be kept to a minimum for two reasons (1) so that the rhythm established by the reader's eyes shall not be disturbed by too great disparities in line length and (2) so that the formation of unpleasant shapes may be reduced, if not altogether avoided. A soft, and flowing edge is to be aimed at. Having determined the maximum measure & requested the typesetter to use a space band of a fourth (m/4) or a fifth (m/5) of an em, certain general guiding principles should then be laid down. For example, the commencing lines of a page—say the first four or five, should never be driven out to full or to nearly full measure & then followed by several shorter lines for this creates a hard shape & often ugly beginning to the page. If single lines, especially the first line (or first two lines) are set in this manner, i.e. with considerably shorter lines following them, then in addition to an ugly shape there will be weakness, for the opening lines will appear unsupported. Conversely the first line or lines of a page should not be set too short of the maximum measure otherwise that corner of the page will be weakened. Similarly at the foot of the page succeeding lines of diminishing measures will produce the same result.

Hard, that is, angular, rigid shapes and also fussy shapes are to be avoided. They are distracting. Convex shapes are to be preferred to concave but even the convex shapes should not be too prominent. A gentle irregularity is undoubtedly best but in the course of any lengthy work there are almost bound to be some pages in which the matter is intractable and the shaping of the page edges unsatisfactory.

Two quotations are apposite here. J. H. Mason, writing on the length of line said: Approximate uniformity in length is desirable; but not absolute uniformity. It is doubtful whether the power of fairly rapid intelligent reading can be attained without the unconscious performance of the swing from near the end of each line to near the beginning of the next... A slight indentation in the lines helps the reader; but a large one hinders the acquisition of a good habit of swing.[1]

In Eric Gill's *An Essay on Typography* published in 1931 by Sheed & Ward Ltd the right-hand edges of the pages were uneven. In this book Gill wrote: Equality of (line) length cannot be obtained without the sacrifice of even spacing. But even spacing is of more importance typographically than equal length. Even spacing is a great assistance to easy reading; hence its pleasantness, for the eye is not vexed by the roughness, jerkiness, restlessness and spottiness which uneven spacing entails, even if such things be reduced to a minimum by careful setting. It may be laid down that even spacing is in itself desirable, that uneven length of lines is not in itself desirable, that both apparently even spacing and equal length of lines may be obtained when the measure allows of over fifteen words to the line, but that the best length for reading is not more than 12 words, & that therefore it is better to sacrifice actual equality of length rather than evenness of spacing, though a measure of compromise is possible so that apparent evenness of spac-

[1] *The Imprint*, February 17th, 1913.

cibile. Alcune agenzie chiedono
iamo sempre tutto quello che
: una cifra molto piccola.
o netto è di 3 sterline su un
vi rimangono 36 scellini. In
tà di questo guadagno viene
E alla fine per gli azionisti
ale.
del 15%, ai tempi in cui
va sul prezzo. Uno che
i da un altro che, dopo aver
iteva lavorare per il 3%.
rzo uomo che aveva per uf-

e fecero a gara nel
avrebbero speso lo stesso
vano ottenere in cambio del
procurarsi i migliori copy-
i di trasmissioni radio.
persone competenti è la ragio-
le agenzia, è molto più basso

:ità, da un'attività com-
c'è riuscito. E' certo che oggi
perti si trovano prevalente-
o della nostra e non nelle

ione avvenuta nella
ricerche di mercato tra i
icurò i servizi di persone di
, professore di ricerche di
, uno dei più noti psicologi

roporzioni vastissime, ma è
nticipò Gallup, Nielsen,
:ramente un iniziatore. Oggi
o che mettono a nudo da-

45

ing be obtained without unpleasant raggedness of the right-hand edge. In other words, working with a 10–12 word line you can have absolute even spacing if you sacrifice equal length, but as this will generally entail a very ragged right-hand edge, the compositor may compromise and, without making his spacing visibly uneven, he can so vary the spaces between words in different lines as to make the right-hand edge not unpleasantly uneven. In any case it is clear that the 10–12 word line and even spacing between words are in themselves of real and paramount importance, while the equality of the length of lines is not of the same importance...

Eric Gill's book was hand-set, and in hand-setting it is possible to control to some extent the shape of the edge of the page: it is visible in the metal. In computerized page make-up it is also theoretically possible to vary the word-spacing from one line to the next, but practically speaking the more or less exact control which the hand-compositor is able to exercise over the setting is impossible from the keyboard. The really intelligent keyboard operator can nevertheless do a great deal to mitigate an ugly raggedness on the right-hand edges of the pages.

Word-division in this kind of setting cannot be dispensed with as some writers on ephemeral printing suggest, without most unpleasant variations in line lengths. But it should be kept to a minimum. The ends of lines should be watched not only for divisions but for the article and indefinite article. All seem to gain an unwanted prominence in irregularly-edged setting.

The student-typographer will realize that galley proofs are, at best, only a general guide to the quality of the ragging for apparently unsatisfactory shapes in the initial proofing may be perfectly satisfactory in the made-up pages: the converse is, of course, true also.

Paragraphing in irregularly-edged setting is even more necessary than it is on the conventionally set page for without some kind

of signalling paragraphs will tend to run on in a confusing way. Normal paragraph indention, especially in pages containing a number of short paragraphs will create the effect of an irregular edge on *both* sides of the page. For this reason paragraph marks (which need choosing with great care) may have to be used to indicate new paragraphs.

Finally, in writing of irregularly-edged setting it must be stated that we are not advocating the abandonment of the conventional method! These notes were written for those who decide to set an occasional book or piece of ephemera in this way—and, wisely, are not to be discouraged by those who decry (usually without good reason) all experiment that is a departure from convention.

THE SETTING OF INITIAL LETTERS

Although initial letters may be called a minor form of display they are mentioned here because a properly set initial is an integral part of the page or column it is set in.

In books, initial letters are often used to mark the beginning of a new chapter. In newspapers & ephemeral printing of all kinds they are used as subsidiary eye-catching devices to direct the reader's eye to the beginning of a piece of copy. Even a casual glance through a book or newspaper reveals initials used in this manner but in many instances it also discloses appallingly careless methods of setting.

Of the many interesting ways of setting initial letters one of the most usual is as a dropped letter. This is unfortunate, for to judge by the majority one sees our compositors find it uncommonly difficult to set them correctly. A dropped initial must fit its text lines snugly: its head should align optically with the top of the opening word or words, which may be in either spaced capitals or small capitals. If the initial happens to be a letter finishing in a sharp point or apex, as in certain forms of the capital A, or it has apexes

as in certain forms of the letters M and N, then the point, or points, should, of course, project *above* the following letters so as to achieve an optical alignment. So much for the head.The foot or feet of a dropped initial should align with the base of the x-height of the adjacent line of text. But if the 'feet' of the letter are pointed as they are frequently in V and W, then the points must project *below* the line in order to get the necessary visual alignment.

The left-hand ends of lines indented to accommodate dropped initials should range exactly, unless the initial is recessed (recessing or mortising means the cutting away of part of the shoulder of a capital in order that an adjacent line can be fitted closely up to it when the letter is used as an initial), a necessary treatment in the case of capitals like A and L, and R when the tail of the latter projects beyond the bowl.With initials of this kind the first line of the paragraph is brought in close to the letter, the succeeding lines being ranged with the side of the body. Of course the dropped initial A may be treated in another way.The left-hand ends of the lines succeeding the first text line may be indented to follow the slope of the stem of the initial, the body of the letter being cut away to make this possible. If the A happens also to be the indefinite article the second word in the first line will need bringing out towards the apex of the initial so that the spacing between the apex and the second word is approximately the same as the spacing between the other words in the line.The degree of movement of this second word leftwards will depend on the design of the font used for the initial & may also be determined to some extent by the word itself for confusion might arise if certain words (especially if they were set in capitals) followed the indefinite article too closely.

Perfect fitting of the foot or feet is necessary with initials which stand on the line (raised initials).There must be no doubt about them standing firmly on the 'line'.

E VEN THOSE HIGH about which the cri trouble, those paint

A ND THE CHILD Lord, and served their fathers, wh Egypt, and followed other

W E GIVE THANK mention of you i without ceasing patience of hope in our Lord

C HRISTOPHE relate more th I owe to the ki was born in 1699, at Blan

T HIS EXCELLENT letter-founder was bound

E VEN THOSE HIGH about which the critics trouble, those paintings

A ND THE CHILDR Lord, and served B their fathers, which Egypt, and followed other

W E GIVE THANKS mention of you in ou without ceasing your patience of hope in our Lord

C HRISTOPHE relate, more than I owe to the kind was born in 1699, at Blan

T HIS EXCELLENT letter-founder was bound

Above, the faults exhibited in the settings of the five initial letters in the left-hand column have been corrected in the examples on the right. See the relevant passages in the text. Unfortunately only parts of the lines adjacent to each initial can be included in the examples. The fine dotted rules indicate the left-hand edges of the columns.

If letters like F, P, T, V, W, and Y are used in this manner they should be kerned sufficiently to make visually even spacing possible between the letters in the remainder of the word if the word is in capitals; or prevent an appearance of dislocation if the remainder of the word is in lower-case. If not properly kerned an unsightly gap appears between the initial and the second letter of the first word.

When used either as dropped or raised initials certain capitals should be set overhanging the text mass, i.e. so that they align optically with the edge of the page. For example, when the initial is a capital T the left-hand serif on the bar and part of the bar should usually project into the margin & round letters like C and O must also project—though only slightly—in order to give a clean or optically aligned left-hand edge. The bottoms of round letters like C and O must, in addition, come slightly below the lines they *appear* to align with or rest on, in order to get visual alignment. Other letters needing similar treatment will suggest themselves to you.

Only two of the many treatments of initial letters have been mentioned, but they indicate the care with which the setting of initials should be treated. Initials must, at all costs, be made to look as though they belonged to their texts.

BY THE TREATMENT OF PARAGRAPHS

The indention of first lines. The indention of the first lines of paragraphs often produces an ugly serration of the left-hand edges of pages or text columns especially when the matter consists of very short paragraphs, e.g. in conversational passages. This effect is exaggerated when the measure is a narrow one. When indention is called for then the first line[1] of the *commencing* paragraph should be

[1] See notes on page 32 for the treatment of paragraphs opening with a quotation.

set full out. This treatment gives the page a strong & clean beginning. It will be found much easier to design a satisfactory chapter or other heading over a full line than over the weak and unshapely beginning which an indention, however slight, would give. Similarly, the first line of a paragraph immediately below a subheading should be set full out. Of course in books with running heads the indention of the text paragraphs makes it almost certain that on several of the pages a new paragraph will commence the page and give the weak shape just referred to. This is unfortunate, but short of re-writing the text at those points such contingencies appear to be unavoidable.

The use of well-designed paragraph marks, either set flush or overhanging the text, should be considered as an alternative means of marking the beginnings of paragraphs.

Perfecting. In the finest bookwork the pages of text are printed in such a manner that the lines on a recto page back up exactly those printed on the reverse or verso side. This care in setting and printing, nullified when extra space is inserted between paragraphs (for there is some show-through even on reasonably good paper), adds to the beauty & clarity of the pages by heightening the contrast between the lines and their interlinear whiting. Students engaged in the production of books, booklets and pamphlets would do well to bear this in mind, so arranging the whiting of subheadings, for instance, that line-for-line backing is possible.[1]

The first word or words of the opening (in bookwork). Various treatments of the opening word, or words, of the first paragraph may be used. For instance, they can be set in letter-spaced capitals provided these are of the kind which are lower than their ascending lower-case letters, e.g. Bembo, Perpetua, etc. The capitals of

[1] In this book, for example, the spacing allowed for headings is based on the unit of *one text line plus its leading.*

other faces, which range with the tops of the ascending letters should be set down in size to prevent them from appearing too large and insistent. Another way of treating the opening words is to set them in letter-spaced capitals and small capitals, or in letter-spaced small capitals with a commencing capital. The method depends to a large extent on the nature of the copy & the job in hand, but whichever is used the capitals must be letter-spaced, for two reasons (a) to give visually even spacing and even colour, and (b) to mitigate the effect, in the case of capitals, of over-emphasis.

In publicity or jobbing work. In ephemeral printing the method of setting the opening word, or words, of the first and of subsequent paragraphs, may be used as a means of enlivening the text and of inviting the possibly unwilling reader to read. For example, paragraph openings in bold italic or in a small size of a colourful script type help considerably in leading the eye into the copy.

Similarly, subheadings, leading in from well outside the text column, & paragraphs which commence with a really large, & possibly decorative figure are all aids to getting the adjacent text read.

If copy is itemized within a paragraph and each item is marked with a figure, then colour, and a visual interest, may be brought in by setting such figures in, say, a small size of a fat face, like Ultra Bodoni. But in this kind of arrangement see that the typesetter does not divorce an item figure from its following text, i.e. by leaving the figure on the right-hand end of a line and starting the relevant copy at the beginning of the next.

Consider in this connection, the use of ranging or modern figures with faces which normally carry only old face numerals, e.g. the use of Times Bold figures with Perpetua Bold upper- & lowercase. Old face figures, used *within* a text, tend to get lost because of their insignificance: and a figure which aligns with its following capital often looks much happier.

METHODS OF DRAWING ATTENTION
TO WORDS OR PHRASES IN A TEXT

If stress has to be laid upon a particular word or words then the usual method is to set in italic.[1] Alternatively words can be set in hair-spaced small capitals,[2] or the words themselves can simply be letter-spaced.[3] The latter method tends to spoil, through weakening, the colour of the line, and thus inevitably, of the page. It can, of course, only be used in an impeccably set text. In a poor setting the effect of the letter-spacing would hardly be noticeable.

The employment of letter-spaced capitals should be reserved for important openings & should not, generally, be used *within* the text because of the restless, spotty effect that they produce.

In ephemeral printing. Capitals are frequently misused in drawing attention to, or emphasizing, a word or phrase within the text of an advertisement, brochure, or booklet. Some advertisers like to see their own names, or the names of their proprietary products, or of the particular services they are offering set as large as possible within the body-matter. If this ambition cannot be entirely curbed it must be circumvented in another way, viz. by setting the capitalized word or phrase in a smaller point size than the remainder of the body-matter. Especially is it necessary to adopt this treatment with faces where the capitals are as high as the ascending lowercase letters. Even with designs like Bembo, Granjon, and Perpetua, in which the capitals are not as high as the ascending lower-

[1] Edward Johnston refers, in his book *Writing and Illuminating, and Lettering,* to using italics for *difference.*

[2] 'Some people', said the late J. H. Mason, RDI, 'speak of using italic for emphasis, but words set in italic (and in small capitals) are not really emphatic but only different, & so conspicuous'.

[3] Hair-spacing is the correct method of drawing attention to a word if the setting is in Greek or in German.

case letters the same method of setting might with advantage be adopted: it depends entirely on the degree of capitalization.

Not this way:
for one thing it has the exclusive 16 mm. distributing rights of famous...films such as 'CÆSAR AND CLEOPATRA', 'HENRY V', 'GREAT EXPECTATIONS', 'ODD MAN OUT', and the American productions of Universal-Interna-

This is infinitely better:
for one thing it has the exclusive 16 mm. distributing rights of famous...films such as *Cæsar and Cleopatra, Henry V, Great Expectations, Odd Man Out*, and the American productions of Universal-International.

But no designer can feel satisfied with a text setting which is peppered with proprietary or other names in capitals, for over-emphasis so often results in no emphasis. Texts of this kind are often, & deserve to be, left unread. A rearrangement of the copy, or, where this is impossible, the setting of the names in italics or in spaced small capitals are other ways of making the copy readable. By its very spottiness and restlessness capitalization or over-emphasis in text matter defeats its object, and instead of inviting, turns the reader away.

The following note applies only to publicity and jobbing work where the reader must be invited to read.

BREAKING UP AND ENLIVENING THE TEXT MASS

Advertisements naturally vary in the amount of 'copy' or reading matter (as distinct from displayed matter) which they contain. When several hundred words of copy have to be set an attempt must be made to break up, & bring interest into, what would otherwise be a dull grey, or solid mass, in the design.[1] There are several

[1] 'Pages of letterpress divided into paragraphs at fairly frequent intervals are more inviting to the eye than those that run on with never a paragraph from top to bottom. I say

ways in which this breaking up can be done:
(a) The first attempt should be by way of the lightening effect of
leading, which tends to make any text more readable than it would
be in solid form. It is better to reduce the body size, say one point
(this small reduction is not, of course, always possible), and lead,
than it is to set the matter in the larger size of type, solid, e.g. 9
point, one point leaded is usually more readable than 10 point set
solid (see LEADING p. 13).

In the relatively small text space of an advertisement it may hap-
pen that a particular composition size is too large to fill the space
comfortably, that is, without overcrowding the lines, and that the
next size down is too small to produce anything but a weak & over-
leaded piece of setting. In such cases the opening lines or the first
paragraph of the text should be set in the larger size & the remain-
der of the copy in the next size downwards in the particular type
range. The aim must be to make the size change downwards as

fairly frequent intervals, however, with intent, for a pointless profusion of paragraphs
seems to me as irritating as their absence is forbidding. The cheaper journalism has
adopted in some quarters the fashion of starting a fresh paragraph with almost every
new sentence...
'This abominable habit of cutting up English periods into contemptible little snippets of
a dozen or so words apiece is presumably due to the notion that that is the only form in
which the reading public can be induced to absorb articles of any length. It is a pity that
editors should rate the intelligence of their readers so low, but the real menace of it is
that if this kind of thing is ladled out to the man in the street for long enough he may in
the course of time really become incapable of digesting anything more solid. It would
seem to me better to reduce paragraphs to a bare minimum than to sprinkle them all
over the page without rhyme or reason in this shoddy fashion; but the soundest policy of
course is to aim at a happy mean'.
Although this quotation from *Mind the Stop* by G. V. Carey was addressed to the au-
thors of books and of articles it should be taken to heart by some advertisement copy-
writers whose 'paragraphs' are even shorter than those instanced in the quotation. A
sentence of less than seven average words noticed recently in the text matter of an ad-
vertisement can surely not be called a paragraph, yet this particular sentence was in-
dented and treated as such! Copywriters who write in this way not only insult possible
readers but make it almost impossible for the typographer to produce decently readable
settings.

gradual as possible.With certain types the difference in near sizes is too marked, while with others the change will almost be unnoticeable.The leading in this style of setting must, of course, be varied to give an appearance of even 'colour' throughout. In other words, if the opening matter is set in 11 point with four point leading, then the remainder, set in 10 point, might be three point leaded.This is a purely hypothetical example: the exact amount of interlinear spacing for each size would depend on the factors mentioned under LEADING (p. 13).

(b) In the editorial type of advertisement, the newspaper method of *shading down* may often be adopted with advantage. For example, an opening set in 11 point could be followed by a paragraph in 10 point.The third paragraph might follow in 9 point & the remainder (& bulk) of the copy in 8 point. Lengthy copy can be made to look more inviting and will be infinitely more readable if this newspaper technique is intelligently used, than it would be if set in one size of type throughout.

(c) Passages can be set in italic, or the whole text can be set in italic—if it is not too long.[1] In itemized copy the actual items can be set in italic, the remainder of the text being in roman.

(d) In long conversational pieces relief can be achieved by the alternate use of roman & italic, in some cases; in others, by the use of ordinary roman with its related bold.The italic brings a change of *rhythm* and the bold face a change of *colour.*

(e) One can often achieve interesting effects in dealing with very lengthy copy by arranging the matter in several columns: the nature of the copy will be the determining factor, e.g. it would be un-

[1] Complete books were set in italic in the sixteenth century, & of course later. And today whole works and long passages in books are still set in italic; *vide* The Heinemann Bible *The Bible designed to be read as Literature* for over a dozen pages of introductory matter all set in leaded Perpetua italic. Eminently readable though it is, roman is generally favoured for continuous reading.

wise to set medical copy in this way for narrow squared-up columns make for frequent word division, see pages 38–41. Both medical & scientific copy contain a large proportion of long words. See the note on multi-column setting under LEADING, p. 17.

To the reader who asked in 1958 'What are your views on uneven edged setting in two or more columns?' I replied 'I would not object to two or three adjacent columns being set with uneven right-hand edges. Why not?' But had I been discourteous enough not to reply he could hardly have helped noticing the gradually increasing volume of text arranged in this way. There is no reason why book or magazine pages or advertisement spaces consisting of a number of columns should always be set in a squared-up manner. Try three, four, five, or more columns set with an uneven right-hand edge, treating in this way not only *narrow* columns but columns set to normal measures also. The effect can be excellent. More generous inter-column whiting will of course be necessary than for similar arrangements where the columns are squared on both edges.

On the following pages we show an opening from the Introduction to *Typomundus 20*, a volume devoted to specimens of typography designed over the last sixty years. All the introductory pages of text in this stimulating work are arranged in like manner, that is, as six-column spreads of apparently-unjustified setting. Not only are these pages visually interesting & commendably readable but the manner of their arrangement provides a satisfactory solution of the problem of handling contiguous translations in their almost inevitably varying lengths.

THE SETTING OF FIGURES AND NUMERALS

Figures need choosing with care especially when used in quantity as in some kinds of tabular matter. Fonts, for example, with this (3) version of the third digit are best avoided due to the risk of mis-

Hermann Zapf
Germany

Typomundus 20 attempts to give an account of the development in typography during the last sixty years the world over. This survey is to show for the future new trends and new techniques in design which have evolved especially since the advent of photocomposition some 15 years ago. Along with the revival of Victorian typography and its use of old fashioned and turn-of-the-century type faces, truly modern designers have always given convincing proof of their efforts to live up to the high standards of contemporary design. Their works are true expressions in thinking for advertising and book design, refraining from all dabbling with elements of the past.
It is to be regretted that the exhibition is limited in space. Some outstanding typographic designers were missing, such as Dwiggins, Updike, Rogers, Mardersteig, Schmoller, Trump, Schneidler etc. Examples of their work were not sent in, and the Jury was restricted in their choice by the limited number of entries in order to include all aspects of typography during the last sixty years.
The study of the masterpieces of this exhibition, however, should not lead to cheap imitations. The respect for the creative achievements of the past and of the present in typographic design should be internationally recognized.
The exhibition as a whole is a good survey of the different sources and styles of the last decades. The visitor can look for his orientation to many representative examples of designers from various countries. Works which show timeless quality will be good yesterday, today and in the future.

Typomundus 20 nous propose une vue panoramique sur l'évolution mondiale de la typographie depuis les 60 dernières années. Cette étude vise à nous éclairer sur les tendances et les techniques apportées au "design" depuis l'avènement de la photocomposition il y a 15 ans. Parallèlement à la renaissance de l'esprit typographique style victorien, et à l'usage fait des caractères fin du 19e siècle, le graphiste contemporain pousse toujours plus loin sa propre évolution. Ses réalisations, libérées des poussières du passé et appliquées à la publicité et aux arts du livre, demeurent une parfaite expression de notre 20e siècle.
Nous regrettons que notre exposition ait eu à se limiter dans l'espace. Des noms célèbres en typographie sont absents, tels: Dwiggins, Updike, Rogers, Mardersteig, Schmoller, Trump, Schneider, etc. Nous n'avons vu aucun specimen de leurs travaux. En plus, le jury a dû, fort à regret, limiter son choix afin de pouvoir donner une juste vue d'ensemble des soixante dernières années. Il faudra veiller à ce que l'intérêt que l'on portera aux grandes réalisations montrées par l'exposition ne soit pas faussé et nous conduise à de vulgaires imitations. Le respect dû aux grandes réalisations du passé et du présent devrait être universellement ressenti.
Cette exposition donc donnera une excellente idée des multiples influences et transformations amenées par ces dernières décades. Le visiteur sera en mesure de retrouver de nombreux specimens des meilleurs travaux produits par les graphistes dans le monde. Les travaux transcendants l'ont été hier, le sont aujourd'hui, et le seront demain.

Typomundus 20 hat es sich zur Aufgabe gestellt, einen Überblick über die Entwicklung der Typografie in den vergangenen sechzig Jahren in der ganzen Welt zu geben. Als Ausstellung will sie für die Zukunft neue Strömungen und neue Entwurfstechniken aufzeigen, die sich besonders seit der Einführung des Fotosatzes vor etwa 15 Jahren herauskristallisiert haben. Neben dem Wiederaufleben der viktorianischen Typografie und ihrer Verwendung altmodischer, aus der Zeit um die Jahrhundertwende stammender Drucktypen, haben die wirklich modernen Entwerfer stets überzeugende Beweise ihrer Bemühungen geliefert, sich den hohen Anforderungen zeitgemässer Gestaltung würdig zu erweisen. Ein aufrichtiger Ausdruck klaren Denkens in der Werbung und in der Buchgestaltung, ohne jegliches Spielen mit Elementen aus der Vergangenheit.
Es ist bedauerlich, dass die Ausstellung im Umfang begrenzt ist. Einige hervorragende Typografen sind nicht vertreten, darunter Dwiggins, Updike, Rogers, Mardersteig, Schmoller, Trump, Schneidler usw. Beispiele ihrer Arbeit waren leider nicht eingesandt worden, und die Jury war in ihrer Auswahl durch die begrenzte Zahl der Einsendungen eingeengt, um alle Aspekte der Typografie der vergangenen sechzig Jahre darstellen zu können.
Das Studium der Meisterwerke in dieser Ausstellung sollte jedoch zu keinen billigen Imitationen verleiten. Die Ausstellung gibt als Ganzes eine gute Übersicht der verschiedenen Quellen und Stile der vergangenen Jahrzehnte. Zu seiner Orientierung kann sich der Beschauer viele repräsentative Arbeiten von Entwerfern aus einer Reihe von Ländern betrachten. Arbeiten von zeitloser Qualität waren gestern gut und sind es heute und werden auch morgen noch gültig sein.

Hiromu Hara
Japan

It was a great honor to me to participate in Typomondus 20 as the only juror from the Asian countries. To my regret, however, besides Japan, no other countries of Asia submitted their works. We still live far from the U.S. and from Europe not only in distance but also in the languages and letters we use. Besides China and Japan, there are many countries in Asia such as India, Burma, Thailand, and Korea which use completely different languages. Speaking of typography in those countries, some of them have not resolved the problem of making good, basic typefaces. Before World War II, the Chinese and the Japanese used common characters called "Kanji" (Chinese), although they had different pronunciations. But, as a result of the recent character reform initiated by New China, even this commonness unfortunately is lost. This trend leads precisely into the opposite direction which our future communications should take. In order to resolve this problem, it is desirable for àll of us to co-operate on the international scale regardless of differences in ideologies or political beliefs. Everyone in the world should be concerned even though this particular problem affects only two countries.

At present, printed Japanese is composed of a minimum of about 2,000 different characters. We don't differentiate between "capital letters" and "lower case". There are only two basic typefaces and there is no distinction between "body type" and "display type".

In spite of these facts, we have made great efforts to develop our typography. As early as 1929, we put photographic composing machines in practice. (The poster by Yamashiro, which obtained the unanimous vote of the jury, was produced with the photo compositor.) Recently, many newspapers began using teletypesetting. The new typo-

graphy originated by the Bauhaus in Germany has had a strong influence on Japanese designers, although it is actually almost impossible to materialize these ideas for practical use in Japan. It has only been recently that young designers in Japan began to wrestle seriously with the problem of typography.

I attended the jury meeting with great interest as well as apprehensions as to how the entries from Japan would be evaluated. I was only looking for a fair evaluation; either overestimation or underestimation would merely increase our problems. The result was rather satisfying; the entries, except for perhaps a few, obtained a just evaluation, I believe. This showed that all the jurors had excellent, discerning eyes. Incidentally, I am sorry that no books were sent from Japan.

Year by year, we in Japan use more typography with European letters which will eventually make it possible for us to compete on an equal basis with the typography of other countries. I am afraid, however that as our typography now stands, it tends to appear monotonous because of the very limited availability of type faces in the present situation.

Ce fut un grand honneur pour moi que de me retrouver à Typomundus 20 le seul représentant des pays asiatiques. C'est à regret cependant que j'ai du constater que de toutes ces contrées, seul le Japon avait envoyé des travaux. Nous vivons·encore fort éloignés des Etats-Unis et de l'Europe, non seulement sur le plan du graphisme, mais aussi par notre langue et les signes de notre alphabet. Songeons que le Japon et la Chine mis à part, les Indes, la Birmanie, le Thaïlande et la Corée ont tous des langues différentes. Plusieurs de ces pays n'ont pas encore réussi à se doter d'un caractère basique et simple. Jusqu'à la déuxième guerre mondiale, la Chine et le Japon utilisaient, malgré une prononciation différente, un même caractère appelé "Kanji" (Chinois). Cependant même cette mince similitude n'existe plus depuis les réformes apportées par le nouvel état chinois. Cette tendance est malheureusement à rebours de ce que devront être les communications dans l'avenir. Ce n'est que par une franche collaboration, indépendante d'idéologies et de crédos politiques, que nous réussirons à contourner de telles difficultés. Personne n'a le droit de se désintéresser de tels problêmes, même s'ils concernent deux pays seulement. De nos jours, le japonais écrit se compose d'un minimum de 2000 caractères. Nous ne différencions pas les capitales et les bas-de-case. Nous comptons seulement deux principales familles de caractères, sans prévisions pour textes et titres. Malgré ces lacunes, nous avons consacré beaucoup d'efforts au développement de notre typographie. Déjà en 1929, nous nous servions de composeuses photographiques. (L'affiche de Yamashiro, qui s'est mérités l'unanimité du jury, a précisément été réalisée sur photocomposeuse.) Depuis quelque temps, de nombreux journaux se servent de télé-composition.

A note on this example from Typomundus 20 *will be found in the text, page 57. The margins shown above are in exact proportion to those of the original, the page depth of which is eleven inches.*

taking 3 for 5 especially when presswork is poor. The best form of the figure three is (3), in both non-ranging and ranging fonts.

D. B. Updike, writing in the second volume of *Printing Types* on the subject of arabic (non-ranging) and modern (ranging) figures said: 'The old-fashioned figures were employed until about 1785, when Hunter introduced into his logarithmic tables the new form called "ranging". In them a larger size was needful for legibility (a glance at the examples below will show that body-size for body-size ranging figures appear to be larger than non-ranging). About 1843 both the Royal Astronomical Society and the Superintendent of the (English) *National Almanac* decided to restore the non-ranging figures'. See page 52 of this book, final paragraph.

If figures occur in name and address settings composed in small capitals the arabic figures in fonts furnished with modern or ranging figures (1234567890) look ungainly. Using smaller figures from the same range when that is possible is an attempt at resolving this problem but unfortunately one which will not be absolutely successful for the figures will look lighter and ranging is not likely to be precise. An alternative is to choose a face with old-face or non-ranging figures (1234567890) but even when the latter are available all but the 1, 2, 0 and, of course, their numerous combinations are likely to look somewhat less than perfect when set with small capitals, the 3, 4, 5, 7 and 9 dropping below, & the 6 and 8, in this context, being as ugly as font-size modern or ranging figures. To ensure ranging in a font equipped with modern figures only, numbers containing 1 and the cipher (0) and their combinations, could be set by using the roman numeral (small capital I) and small capital (O).

<div style="text-align:center">

e.g. IIO CROMWELL ROAD • CLERKENWELL • ECI

rather than

110 CROMWELL ROAD • CLERKENWELL • EC1

</div>

Many faces are of course provided with both old-face & modern figures. Useful notes on the setting of figures and numerals will be found in Horace Hart's *Rules for Compositors and Readers.*

The Setting of Displayed Matter

The application of three of the fundamentals of good typography to the setting of text or body-matter has been discussed in the first part of this book. In the setting of displayed matter, both in its minor & in its major forms, it is obvious that these fundamentals can also be applied, though naturally there will be less need, & opportunity, to bring the principles governing the second of them (determining the measure) into use.

Recapitulating, and making a very necessary addition, it will be found that the essentials by which all good displayed setting is governed are three in number, namely the right treatment of letter-spacing, word-spacing, and leading.

LETTER-SPACING

CAPITALS

When space permits the capitals in a setting should be letter-spaced and the spacing must be so varied between each pair of letters as to secure the *appearance* of even spacing through the whole word, or group of words. If the setting is of more than one line then

optically even letter-spacing must be achieved *throughout* the setting. A line which is slightly shorter than its neighbours must never be forced to make the same measure as the adjacent lines by increasing the letter- (or word-) spacing otherwise the colour of that particular line will be weakened and its patchy colour will destroy the unity of the whole of that part of the setting. Unfortunately both the misuse of letter- (and word-) spacing in the forcing of

1 SORBONNE SORBONNE

2 FINER POINTS
IN THE SPACING
& ARRANGEMENT
OF TYPE · PART I

3 FINER POINTS
IN THE SPACING
& ARRANGEMENT
OF TYPE·PART I

4 THE CAMPAIGN STARTS

1 shows a mechanically letter-spaced word and a revised setting with correct, that is, optical spacing. 2 The misuse of letter-spacing in lines one and four and of word-spacing in line two (because of a misguided insistence on squaring the four lines), and the complete absence of letter-spacing in line three not only destroys the unity of the setting as a whole but shows how these mal-practices of spacing (both, in this example, mechanical), aggravated as they are by the inadequate leading, tend to create a vertical eye movement. In 3 the complete setting is optically letter- and word-spaced, the latter being no more than sufficient to separate the words. Each line was allowed to make its own measure and was then centred optically. Notice that the leading is sufficient to separate the lines comfortably. This example is an attempt to demonstrate perfection in spacing—not in arrangement. Example 4 is referred to in the first full paragraph on page 65.

lines and the *mechanically* even spacing of lines of capitals are common practices today. Admittedly mechanical spacing is somewhat quicker and therefore slightly cheaper than optical spacing, but it usually looks wrong, and is, in those cases, a sign of slovenly 'workmanship'.

If, on occasion, a line of capitals has to be set solid, i.e. without letter-spacing then some mitigation of the inevitably poor letter-spacing will be possible if the line contains letter combinations like PA, TA, and RT as does Example 4, opposite. These can be mortised & the ugly word-dividing whites appearing in (4) be thus reduced. Other pairs of letters which can, in similar circumstances, be subjected to the same treatment will suggest themselves.

UPPER- AND LOWER-CASE

Displayed settings in upper- and lower-case are usually not letter-spaced. If letter-spacing is necessary however the rules which govern the spacing of capitals must also be applied, i.e. the spacing between the letters must be made visually even throughout. Letter-spaced lines of upper- and lower-case must never be placed in juxtaposition with lines which are not letter-spaced for the reason given under CAPITALS (see p. 63).

WORD-SPACING

CAPITALS, AND UPPER- AND LOWER-CASE

The word-spacing in displayed lines should be fairly close for one must aim at achieving the effect of a line and not of a series of isolated spots. And, of course, the word-spacing must be *visually* and not mechanically even, for only in rare instances will the latter kind of spacing satisfy the eye. This rule applies equally to the three-words-in-one-line and the multi-line setting (in any given point size). The word-spacing after apostrophes must always be

watched carefully. It often appears to need increasing very slightly to offset the white introduced by the apostrophe.

If the lines, either of capitals, or of upper- and lower-case are letter-spaced & the letter-spacing is for any reason increased then it is essential that the word-spacing in those lines should be increased proportionately to prevent the words running together. In such an instance the leading must also be increased. See below.

LEADING

CAPITALS

Displayed lines set in the same size of letter-spaced capitals need leading sufficiently to separate them comfortably. The leading will be *mechanically* even, except between lines which contain descending capitals, i.e. certain characters like J, Q, and *R*. The spacing between a line containing descending capitals & any adjacent line below may need slightly increasing to give a visually even effect.

If the letter-spacing and word-spacing in a multi-line setting are increased then the leading must also be increased. This will prevent that feeling of vertical emphasis (see pp. 5 & 16) and confusion which so frequently make properly letter-spaced & word-spaced, but inadequately leaded, lines of capitals, unreadable.

UPPER- AND LOWER-CASE

Whereas the leading of lines of capitals is mechanical, except in rare instances, the leading of lines set in upper- and lower-case demands the same nicety of judgement as does the optical spacing of letters and words because the ascending and descending letters determine the amount of the interlinear whiting. If displayed lines in upper- & lower-case are mechanically leaded, then, in the majority of cases they will not appear to be properly spaced. Care is

66

necessary in adjusting the leading of the lines so as to give visually even spacing *between* them. As the number of lines in a title, for example, increases, so does the problem of leading; and this problem of visual spacing is further increased when words in, or lines of, capitals, are introduced into the setting. The patchy colour produced by improperly leaded lines of upper- & lower-case must be avoided at all costs.

1 A typographic primer:
FINER POINTS
in the Spacing and
Arrangement of Type

2 A typographic primer:
FINER POINTS
in the Spacing and
Arrangement of Type

In 1 the word-spacing, letter-spacing & leading are mechanically even. This treatment of the leading makes the first two lines appear to be too close together. In 2 the word-spacing has been made visually even throughout the setting except between the last two words of the fourth line where the spacing is as close as the type allows. The capitals are optically spaced, and the leading has been made visually even by inserting more between the first two lines. In an actual job the lines would be rearranged to avoid the third line ending as it does.

OTHER FACTORS
AFFECTING DISPLAYED SETTINGS

If, in the designing of displayed settings, the letter-spacing, word-spacing, and interlinear spacing or leading of the lines is intelligently and sensitively handled, then much will have been done towards the excellence of the final work. But apart from attention to the spacing *setwise* and *depthwise*, there are several other factors to be considered. Some of these finer points have been mentioned in PART ONE of this book but are repeated here because they apply with even greater force (through magnification of the type sizes!) to displayed settings.

THE OPTICAL CENTRING OF LINES

Lines that are intended to be centred laterally, for example, the single line chapter heading, or the group of displayed lines in a long title (on a title page, or in the long caption of a symmetrically designed advertisement or poster), are commonly found to be mechanically and not visually centred. This false centring occurs whether the title is set in capitals or in upper- and lower-case, because no account has been taken of the *shapes* of the letters which begin and end the line or lines. Careful placing laterally, either to the left or to the right of the mechanical centre, is necessary to make lines which begin with A, C, G, J, O, Q, T, V, W, Y and c, e, j, o, q, v, w, and y or end with A, D, F, K, L, O, P, Q, R, T, V, W, Y and b, c, e, f, h, p, r, v, w and y, *appear* centred. These letters are the fairly obvious ones, but of course much depends on the design of the font, that is, its lateral compression or widening, weight, etc. and it is true to say that the nearer the letters approach classical Roman proportions the more subtle is the task of centring likely to become.

Apart from letters, marks of punctuation and peculiars are frequently the cause of lines not centring optically. For example, one

often sees displayed lines—possibly a two or three line headline—in which perhaps the third line begins or ends with a dash. If all the lines are arranged to centre on one another the compositor will, almost invariably, centre them all mechanically. This is wrong. What the compositor must be asked to do is to centre the line containing the dash, visually, that is to say, move the line to the left or to the right of the *mechanical* centre, until, in proof, it appears centred to the eye. In practice, this often amounts to disregarding the dash entirely. Lines which begin or end with a star, an asterisk,

THE THE
BOOK ₁ BOOK
Hebrew— Hebrew—
Great Primer ₂ Great Primer
'THE 'THE
HOLY HOLY
BIBLE' ₃ BIBLE'

In 1, left, the centring of the first line is mechanical, no account having been taken of the shape of the first capital. In 1, right, it is corrected, i.e. optical. (2), left, shows how a line is thrown out of visual centre by a dash and how this effect is increased because the lower line ends with an r. (2), right, shows the same line visually centred. In 3, left, the mechanical and slovenly arrangement of the lines has been further worsened by the opening and closing quotes and by the shapes of the capitals T and Y. In 3, right, the lines are visually centred.

a dagger or other peculiar or with the marks of omission (ellipsis...) must be similarly treated.

If a headline of two or more lines is enclosed within quotation marks then the first & last lines must be centred visually. In practice, this again, often amounts to disregarding these punctuation marks entirely, that is, centring the lines as though the quotation marks were absent.

OPTICAL ALIGNMENT OF THE ENDS OF LINES

In asymmetrical layouts (where there is more than one display line) the ranging of the lines on the left or on the right *must never be mechanical,* unless the letters commencing (a) lines squared on the left, happen to be the straight-backed B, D, E, F, H, I, K, L, N, P, R or b, f, h, i, k, l, m, n, p, r, t, or ending (b) lines squared on the

The [1]	The [2]	"Art thou [3] a king then?"
Golden	Golden	
Eagle	Eagle	'Art thou [4] a king then?'

Marks of punctuation— quotation marks, dashes, and certain peculiars
[5]

Marks of punctuation— quotation marks, dashes, and certain peculiars
[6]

In 1 the ragged shape on the left is caused by mechanical alignment of the lines. 2 shows corrected (visual) alignment giving a clean edge on the left. In 3 the double quotes and the shape of the A have made the first line look indented. In 4 the single quote and part of the A overhang on the left to give visual alignment with the line below. In 5 the lines do range on the right—mechanically. But the ugly shape so created has been changed in 6 and a strong edge made by allowing the dash and comma to overhang the measure. Note also the improvement in the shaping of the lines on the left.

right, happen to be H, I, N, U (with straight stem on the right) or d, i, l, m, n, q, u. But if in (a) the lines begin with, or in (b) end with certain of the round letters, or the letters with diagonal strokes, e.g. A, V, W, Y and v, w and y; or the splayed capital M or capital T, then alignment mechanically is bad typography. Letters of this kind must project a little (in the case of the capital T, often considerably) beyond the squared edge of the setting so as to avoid the unpleasantly ragged edge which purely mechanical alignment would give.

Marks of punctuation, for example, dashes & quotation marks, and certain peculiars (* † etc.) occurring at the beginnings or ends of lines which are squared must be set overhanging the measure, when space permits. If there is insufficient space then some of these marks, e.g. single quotation marks can actually be set above the first letter (or last letter, in the case of a closing quotation mark) if the interlinear spacing allows. Attention to details like this improves a setting tremendously. The naturally enlarged size of all marks of punctuation in display sizes increases their prominence. Setting outside the measure is one of the methods that helps to minimize the spottiness of the marks themselves & the ugly shapes that they create if set in the normal manner. Even in text setting, in special cases, the *ends* of lines can be optically aligned by setting punctuation marks, e.g. points, commas, etc. *outside* the measure in a squared-up setting.

'The eye', stated Jaugeon, 'is the sovereign ruler of taste.' Design, in this, as in many other aspects of typography, cannot be governed by mechanical devices of any kind.

DIVISION OF LINES BY SENSE

When the space & the copy permit, and division is necessary, long titles or headlines should be broken up in such a way as to make the sense of each part complete in itself. There is no doubt that lines

ABCDE

FGHJMPTV

Ex Na Qu Qu Ra

e k m s v

as ct et fr gg gy ij is

ll nt sp st ta tt

us zy

A B C D E F G H J K M P T V

Ex Na Ne Ni No Nu

QU Qu Qu Ra Re Ri Ro Ru

e k m s v

as ct et fr gg gj gy ij is ky ll nt sp st ta tt us zy

ſ ſa ſb ſc ſe ſh ſi ſk ſl ſo ſſ ſs ß ſt ſu

ſa ſſa ſſe ſſi ſſl ſſo ſſu

Above are shown swash and ligatured characters available with some display and composition sizes of Monotype 'Garamond', Series 156. Very beautiful lower-case terminal letters, and long s ligatures, are available with Caslon Old Face (Stephenson Blake).

72

which are so treated are not only more readily intelligible but are also *easier* to read than lines which end with conjunctions or prepositions: or the definite or indefinite articles (see page 38 for the TREATMENT OF NARROW MEASURE SETTINGS). Of course, in breaking up a long title or headline word division should, if possible, be avoided.

THE USE OF SWASH LETTERS

The dozen or so special single italic capitals or swash letters supplied with Caslon Old Face, for example, are reinforced in 'Garamond' by a number of logotypes—swash initials followed by an italic lower-case letter in each case—a range of tied letters, as *is*, *sp, us*, and a number of swash lower-case letters some of which can only be used in the middle of a word while others can only be employed to commence, and others to end, words or lines. The American Type Founders version of Garamond italic and of Garamond Bold italic have, in addition to swash letters, a very useful logotypeThe, a range of tied letters, including, in the former face, many combinations of the long s for settings in which a pre-1775 style may have to be adopted.

These useful adjuncts of many old-face italics and some twentieth century faces, e.g. Lutetia and Cancelleresca Bastarda can, when used with imagination and care, impart a feeling of liveliness to a setting but too often one sees them used in the manner shown in the example on page 74.

QUOTATION MARKS AND APOSTROPHES

The notes on pages 30–32 (with obvious exceptions) relating to the setting of quotation marks in text matter, apply also to the setting of these marks of punctuation in displayed work.

But as type bodies increase in size, the number of punctuation marks that it is necessary to watch multiplies. Beware of using

The Priceless Ingredient

In the City of Baghdad lived Hakim the Wise One, and many people went to him for counsel which he gave freely to all, asking nothing in return. There came to him a young man who had spent much but got little, and said: "Tell me, Wise One, what shall I do to receive the most for that which I spend?" Hakim answered: "A thing that is bought or sold has no value unless it contains that which cannot be bought or sold. Look for the Priceless Ingredient." "But what is the Priceless Ingredient?" asked the young man. Spoke then the Wise One: "My Son, the Priceless Ingredient of every product in the Market-place is the Honour and Integrity of him who makes it. Consider his name before you buy."

Fine carpets from Lidchi with Confidence

A full page from the South African Tatler *(10³/₄ × 8ins) shows seven of the eleven swash letters, designed for use as finials, misused as word-rupturing medials. The text, an ugly piece of setting, is riven with faults. Notice the usually over-wide word-spacing which varies even within lines and the unnecessary (with this particular copy) double quotes. Immense improvement would have resulted from thin word-spacing all lines and ranging left especially if the words/and/freely/a young/Tell/My/the/who/had been taken down and the 'is' in the seventh line taken up. Another three or four points between the lines is a further much needed revision. The border round the original advertisement & the small L symbol block between the last line of the text and the footline have been omitted in order to make our reproduction as large as possible.*

74

over-large quotation marks, e.g. those designed for use with Gill Extra Bold or Ultra Bodoni. They are gross, and like most gross things, ugly. If quotation marks must appear in settings in these types they should generally be set two sizes smaller than the body size of the words they enclose. To save the cost of justification, on some occasions the same size of the related bold might be used.

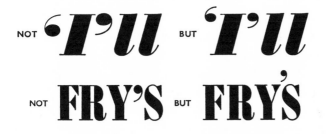

Often it is possible to omit quotation marks altogether in headlines without any obscuration of the sense & with an immense improvement in the appearance of the setting. This improvement in looks is especially noticeable in fonts with extremely ugly quotation marks, e.g. in Rockwell & other members of the Egyptian family of faces. If it is impossible to avoid enclosing a displayed line in an Egyptian face in these marks, then those from some other font should be chosen, e.g. Erbar, or normal round ones of the right weight.

The remarks on size apply equally to the setting of apostrophes, colons, semi-colons, commas, and full points.

HYPHENS, DASHES, PARENTHESES AND BRACKETS

The notes under this heading in PART ONE of this book (see page 34) may be applied to settings in display sizes also. In brief, when hyphens &/or dashes are used with capitals they must be raised so

that they are centred on the *depth of the face* of the capitals (in certain titling fonts the hyphens and dashes are designed to do this, e.g. Perpetua Titling); and when they occur in displayed lines of upper- and lower-case they must be centred on the x-height.[1] But surely, it may be said, the last remark is unnecessary: centring will be automatic on the letters of x-height. However, poor design or poor execution by the manufacturer of the original font design may necessitate manual centring of hyphens and dashes.

Both hyphens & dashes should harmonize in weight, or colour, with the type used. Often one sees, especially in displayed work, hyphens &/or dashes (more especially the latter), drawing attention to themselves because they are too light or too heavy. Here it is apposite to add a note on the centred full points used to separate items in displayed matter or the pounds & pence in price settings. They should be set with the same care also, matching in weight the letters or figures of the faces with which they are used.

NOT Re-cover BUT Re-cover
NOT extra – BUT extra–

Dashes should be separated from the words they relate to by a hair space and must always be of sufficient length. It should not be possible to confuse them with hyphens!

Parentheses and brackets used with display sizes should be set in the same manner as those used with the composition sizes (see

[1] In this connection readers may like to look at Stephenson Blake's grotesque named IMPACT designed by Geoffrey Lee, 1965.

p. 34). In the first of the examples below, set in 30pt Perpetua Bold, the dropping of the parentheses when used with the capitals of the font is an imperfection which only one founder, to our knowledge, is beginning to remedy. In the second example, which

STAR (PAPERS) LTD
STAR (PAPERS) LTD

is set in 18pt Perpetua Bold Titling, the tidier, cleaner line given by parentheses designed for setting with capitals is immediately apparent.

AMPERSANDS

The use of the short 'and' (&) is desirable in all forms of displayed setting where the conjunction in full would either take up too much space or draw an undesirable amount of attention to itself. In text setting (see p. 23), the most appropriate ampersands are those which, by virtue of design and size, are reticent. But in displayed work occasionally the reverse holds good; then the use of a flowery version of the & can add a touch of gaiety to the setting. Among these less regular forms of the & those that are not readily distinguishable should be avoided.

EMPHASIS IN DISPLAYED SETTINGS

Underlining as a method of emphasizing a word or phrase in a displayed setting is a crude relic of Victorian typography. Emphasis can, & should, be achieved in other ways, for example by the judi-

cious use of capitals, or bold capitals, or by the use of roman or italic bold or extra heavy types in upper- and lower-case.

If one is compelled to underline then the underlining must be properly done. The rule must be close to 'the line' or feet of the letters. Where there is a descender, the rule should be set on each side of it. When a descender comes at the beginning or end of a word in lower-case that has to be underlined, set the rule fairly close to the feet of the non-descending letters only. Do not allow the rules used in underlining to straggle visually, even a little, on

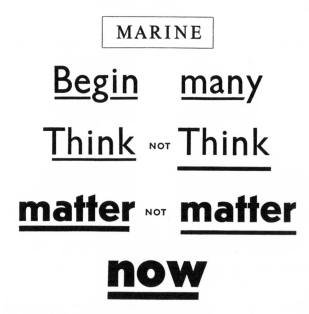

When underlining is employed the rules used should be of the same weight, or as nearly as possible the same weight, visually, as the stems of the letters they underline. Notice that the rule used in underlining many *is cut off at an angle at its right-hand end, the angle corresponding with the slope of the tail of the* y. *But even with the most careful setting underlining remains an ugly way of emphasizing a word or a phrase.*

either side of the word or words that they are stressing. Occasionally attention may be drawn to a single word in a displayed setting by surrounding it with a fine rule, i.e. framing it, as in the example on p. 78.

LINES OF NEAR MEASURES

In display & subsidiary display, lines of very nearly the same measure should not appear in juxtaposition. If so placed they worry the eye. It is better to make such lines either (a) of very different length, or (b) of the same length, by a rearrangement of the matter in them, or by a change in 'copy'. Lines of almost the same length should *not* be made to accord in measure by word-spacing or by letter-spacing, that is, by driving out the shorter line. This is to misuse spacing material, weaken the line so treated, and produce patchy colour in that part of the setting.

THE VERTICAL SETTING OF LINES

Occasionally display lines are set vertically. If it is appropriate to treat an unimportant line or lines in this way—certainly important lines should not be so treated—it makes for easier comprehension and a much cleaner and therefore stronger pattern if the line is set normally & then placed on one or other of its ends and not set with the letters the right way up, and one below the other.

Apart from these advantages the normal line setting placed on one or other of its ends, that is with the *feet* of the letters facing left or right, will practically always occupy less depth, (except in the case of wide faces, e.g. Stephenson Blake's Wide Latin), & where Mm or Ww occur, less width, than the setting with letters placed the normal way up but one below the other—even when beards are cut in the case of expendable sorts, or reproduction proofs, paste-ups, & line engravings resorted to in the case of precious founders' types. That the latter method is likely to produce untidy and often

ugly outlines, whether the settings are in upper- or in lower-case, will be seen from the examples below; and that it is also likely to produce weak lines, and lines which, if not indecipherable, are not easy to read at a glance, can be seen from the same illustrations. The settings in grotesque are from a 5-inch double advertisement.

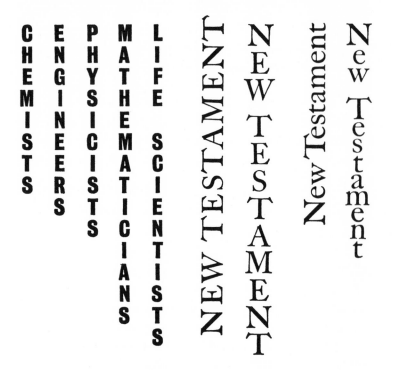

UNNECESSARY PUNCTUATION

Much displayed setting is made unnecessarily fussy by over-punctuation. In some lines punctuation marks of every kind can profitably be dispensed with. Not only is the clarity of the sense undisturbed but there is a great improvement in the appearance of the setting. And the absence of these marks will improve not only

major forms of display but in minor ones, e.g. the name & address lines on title pages, in letter-headings and in advertisements,[1] all notorious for over-punctuation, this improvement in quality is at once noticeable when reliance is placed on the separating effect of white space alone. If a client insists on some form of punctuation in lines of this kind, then in place of commas centred full points (on the *face* of the capitals if the line is in capitals—and on the x-height if the line is in upper- & lower-case) make for a less fidgety effect. Points should not be inserted between postal letters and numbers.

THE EFFECTIVE USE OF WHITE SPACE

The use of over-large type faces is not always, nor is it even generally, synonymous with the most effective display. Frequently in the advertisement pages of magazines one sees displayed lines which are too large to be read comfortably at the normal distance. Typographic clumsiness or bludgeoning of this kind is less telling than arrangements in smaller, more generously leaded type would be. For example, if a setting is to be in a bold upper- & lower-case or in bold capitals the choice of 18pt Erbar Bold italic instead of 24pt Gill Bold italic will be found to make a much more effective setting. Why? Simply because some of our bold display faces are mere paper coverers. By using a smaller, blacker face, that is, one with plenty of colour in it, one achieves better display partly because in reducing the size one gives the lines just that little extra surrounding white—and isolation—which makes the (often startling) difference. In fact, by using a smaller size one may even save a

[1] In certain display faces unusually shaped marks of punctuation occur. For example, the full points designed for use with Erbar Bold italic are of this...shape. In the larger sizes they are ugly & are best replaced by normal circular full points. Besides the shape of punctuation marks their size must also be considered. Some fonts, e.g. Gill Bold Condensed, have over-large commas and apostrophes. In a line of 30 point Gill Bold Condensed, where commas occur, immediate improvement in the quality of the setting is effected by setting these one or two sizes smaller.

line and use the saved space to increase the value of the display. Often one sees settings in which white space has been eaten up by the use of too large a type and/or the multiplication of lines, e.g. what could have been a properly whited five line setting becomes a much less effective seven line one. The value of rightly used white space in displayed settings cannot be stressed too strongly. It can of course be misused as in the example described on page 14.

Apart from the right choice of size the grouping of displayed lines is important. The multiplication of units in a design—and the use of a too abundant variety of near sizes of type, in a title page for example (only a master can handle typographic nuances of this kind); the emphasizing of unimportant prepositions and conjunctions by setting them on lines of their own where, maybe, their loss in size is more than compensated for by isolation, are points which must be considered carefully before a layout is sent to the typesetter, for the misuse of material in these ways can, and so often does, produce restless, bitty effects.

ILLUSTRATIONS

Although this book is devoted to some of the finer points in the spacing and arrangement of type we include a note on illustrations because they are so frequently the cause of awkward word-spacing problems when they are placed *within* the text mass. The even colour of properly composed lines and pages is often disturbed by blocks which occupy only part of the type area, especially when they are squared-up and the adjacent setting is treated rigidly (see page 38 for notes on the TREATMENT OF NARROW MEASURE SETTINGS). With illustrations which are free in outline a less rigid treatment of the adjacent setting may be possible and desirable.

An interesting note on this subject appears in a booklet[1] on

[1] *House Style, Rules for Compositors and Readers* published by Thomas Nelson and Sons Limited, Edinburgh. February 1948.

house style which was published in 1948. It reads: In technical works, wherever two or more small diagrams would fall on one page they should if possible be grouped together so as to spread across the type area rather than appear separately and involve indenting and overrunning.

THE PREPARATION OF THE MS FOR THE TYPESETTER

Having written of some of those finer points which are present in every really good setting—whether it is of a lengthy and permanent nature (as in books), or is comparatively short and ephemeral (as in publicity matter), it must be stressed, once again, how *very* important it is that all MSS or 'copy' for the typesetter should be examined and marked *before* it is sent. All unnecessary punctuation marks should be deleted; the size (in the case of a book) of subheads, etc. marked; paragraph indention, if any, indicated as well as the treatment of the first lines of opening paragraphs; and if initial letters are used they must be specified. Words or passages in italic or in small capitals should be clearly marked; and the treatment of long quotations and footnotes must be indicated. A little time spent on this preliminary marking saves not only time but those costly resetting charges occasioned when such marking is left until the MS is in proof.

BIBLIOGRAPHY

Beaujon, Paul. *The Book of Verse.* An essay in the *Monotype Recorder* Vol 35, No 2. Summer 1936.

Collins, F. Howard. *Authors' and Printers' Dictionary.* 10th ed. Oxford University Press 1956.

Fowler, H. W. *A Dictionary of Modern English Usage.* 2nd ed. Oxford University Press 1983.

Fowler, H. W. & F. G. Fowler. *The King's English.* 3rd ed. Oxford University Press 1936.

Gill, Eric. *An Essay on Typography.* David R. Godine, Boston, MA 1993.

Glaister, Geoffrey Ashall. *Glaister's Glossary of the Book.* Allen and Unwin, London 1960, 1979.

Gottschall, Edward M., ed. *Typographic Directions.* Art Directions Book Co, New York 1964.

The Imprint (magazine), 9 issues. London 1913.

Johnson, A. F. *One Hundred Title-Pages 1500–1800.* John Lane, London 1928.

Johnson, A. F. *Type Designs. Their History and Development.* 2nd ed. Grafton & Co, London 1959.

Johnston, Edward. *Writing and Illuminating, and Lettering.* Pitman, London 1977.

Legros, L. A. and J. C. Grant. *Typographical Printing-Surfaces.* Longmans, Green & Co, London 1916.

The Library. Fourth Series. Vol 24, Nos 1, 2. June–September 1943.

Mason, J. H., RDI. *Essay on Printing* in *Fifteen Craftsmen on their Crafts.* Sylvan Press, London 1945.

Morison, Stanley. *First Principles of Typography.* Cambridge University Press 1951.

Morison, Stanley et al. *A Tally of Types.* 2nd ed. Cambridge University Press 1973.

Morison, Stanley. *The Typographic Arts.* Sylvan Press, London 1949.

Reed, Talbot Baines. *A History of the Old English Letter Foundries.* Faber and Faber, London 1952.

Rogers, Bruce. *Paragraphs on Printing.* Dover Publications, New York 1980.

Rogers, Bruce. *PI.* The World Publishing Co, Cleveland & New York 1953.

Southward, John. *Practical Printing.* The *Printer's Register* Office, London 1911.

Sutton, James and Alan Bartram. *An Atlas of Typeforms.* Lund Humphries, London 1968.

Thompson, Sir Edward Maunde. *An Introduction to Greek and Latin Palaeography.* Clarendon Press, Oxford 1912.

Tschichold, Jan. *Asymmetric Typography.* Faber and Faber, London 1967.

Tschichold, Jan. *The Form of the Book.* ed. Robert Bringhurst. Hartley & Marks, Vancouver, BC 1991.

Updike, D. B. *Printing Types, Their History, Forms, and Use.* 2nd ed. 2 vols. Harvard University Press, Cambridge, MA 1937.

Warde, Beatrice. *The Crystal Goblet.* Sylvan Press, London 1955.

STYLE REFERENCES

Bringhurst, Robert. *The Elements of Typographic Style.* Hartley & Marks, Vancouver, BC 1992.

Carey, G. V. *Mind the Stop: A Brief Guide to Punctuation.* Cambridge University Press 1948. Rev. ed. Penguin Books, Hammondsworth 1958, 1971.

Chicago Manual of Style. 13th ed. University of Chicago Press 1982.

Hart's Rules for Compositors. 39th ed. Oxford University Press 1983.

McLean, Ruari. *Thames & Hudson Manual of Typography.* Thames & Hudson, London 1980.

Milford, Humphrey. *Rules for Compositors and Readers at the University Press, Oxford.* 31st ed. London 1938.

INDEX

The text of this book
was typeset
by The Typeworks
in 10½/14 Ehrhardt.

It has been printed on
Glatfelter Laid Offset
by Thomson-Shore Inc.
Dexter, MI.